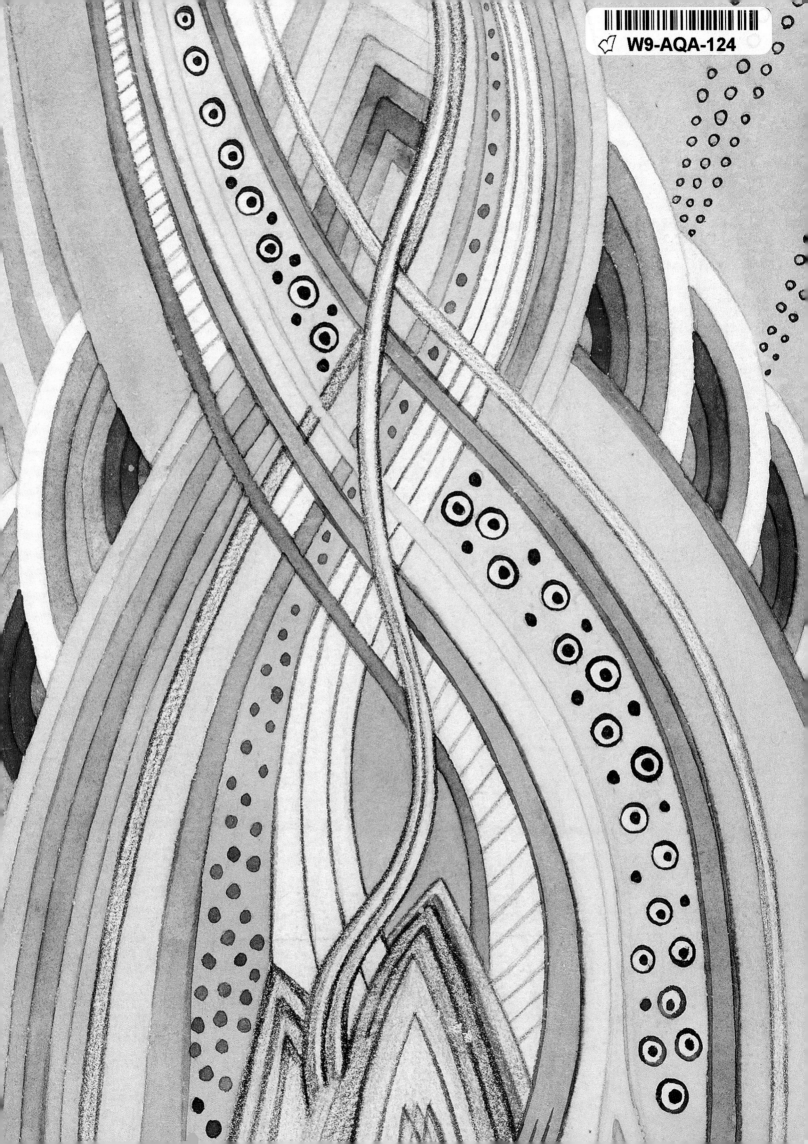

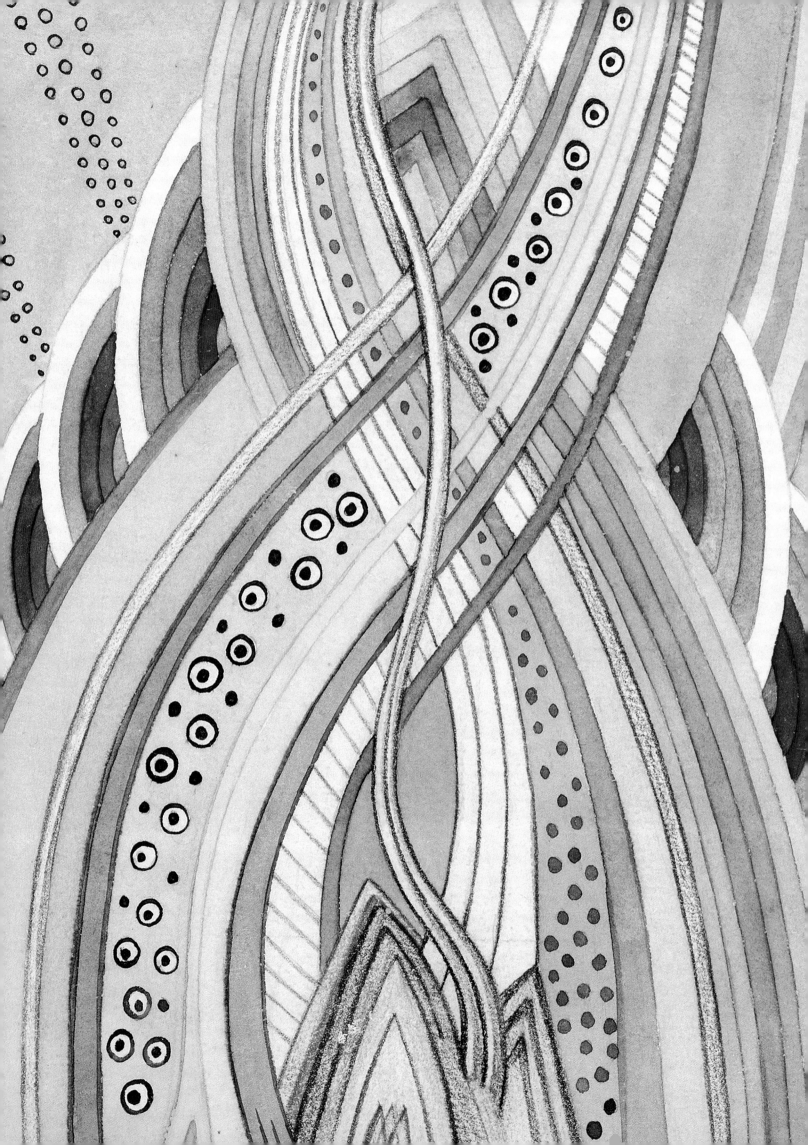

OKLAHOMA MODERNE
Art + Design

OLINKA HRDY

The Art and Design of Olinka Hrdy

Fred Jones Jr. Museum of Art
The University of Oklahoma

This catalogue has been published in conjunction with the exhibition
Oklahoma Moderne: The Art and Design of Olinka Hrdy at the
Fred Jones Jr. Museum of Art,
June 9-September 9, 2007.

Catalogue author: Mark Andrew White
Catalogue design: Eric H. Anderson
Photography: Konrad Eek unless noted.

Fred Jones Jr. Museum of Art
The University of Oklahoma
555 Elm Avenue
Norman, Oklahoma 73019-3003
phone: 405.325.3272; fax: 405.325.7696
www.ou.edu/fjjma

Library of Congress control number: 2007928026
ISBN: 0971718741

Cover:
Studies for Tulsa Riverside Studio Murals, 1928-29
Watercolor on paper; 18 x 4½" (unless noted)

Front Cover (left to right):
String Music
Orchestra Music
Primitive Music
Choral Music
Music of the Future

Back cover (left to right):
Symphony of the Arts (23¾ x 10½")
Modern American Music
Vocal Music
Piano Music

This catalogue was printed by the University of Oklahoma
Printing Services and is issued by the University of Oklahoma.
1000 copies have been printed and distributed at no cost to
the taxpayers of Oklahoma.

OKLAHOMA MODERNE

Art + Design

OLINKA HRDY

Introduction

In the fall of 1995, I had the good fortune to be introduced to the personality of Olinka Hrdy by the Oklahoma artist Leonard Good. As we walked through the museum galleries, looking at works by early University of Oklahoma art students, Good began to tell stories about them. Hrdy and Good were students together at OU during the 1920s while Oscar Brousse Jacobson was overseeing the University's fledgling art collection as the director of the School of Art. When we came to a work by Olinka Hrdy, Good stopped and smiled. I wish I could remember his exact words, but in essence he spoke about a lovely and highly unconventional young woman who was his classmate and friend. Hrdy's art had long been a personal favorite of mine, and while my interest began with her art, it turned into intrigue and delight as I learned about her life.

The known facts about her life include her days growing up in Prague, Oklahoma, an area settled by Czechs. Her second cousin was Edward Beneš, the second president of Czechoslovakia. She arrived at the university with only fifty dollars for the entire year. Befriended by art faculty, she was given opportunities to paint her way through school with mural projects. After spending most of her career in New York and California, she returned to Oklahoma in the 1960s and gave a collection of her work to the University of Oklahoma's art museum, making the Fred Jones Jr. Museum of Art the largest repository of her work. During the 1990s, there was a renewed interest in Hrdy's art and her work was included in the exhibition and catalogue *Independent Spirits: Women Painters of the American West 1890-1945*, as well as the publications *California Art: 450 Years of Painting* and *Tulsa Art Deco*.

I am greatly indebted to Mark Andrew White for accepting the challenge to investigate the career of this fascinating woman. Although the scarcity of information on Hrdy presented a challenge, White has woven the pieces of information together masterfully. His essay guides us through the development of Hrdy's career and captures her personality and unique spirit. The word "hrdý" in Czech means "proud." The Fred Jones Jr. Museum of Art is very proud to be part of an exhibition that celebrates Olinka Hrdy and contributes to the scholarly investigation of her life's work.

In addition, I would like to thank the Harris Foundation for their generous contribution toward the production of this publication. Thanks go to the Oklahoma Centennial Commission for designating *Oklahoma Moderne: The Art and Design of Olinka Hrdy* as an official Oklahoma Centennial exhibition. I also want to thank Eric Lee and the entire staff of the Fred Jones Jr. Museum of Art. I wish to thank Sarah Iselin for editing the catalogue and Eric Anderson for designing it. Finally, I want to thank Richard Townsend, Laura Riley, and our colleagues at Price Tower Arts Center for their collaboration.

Gail Kana Anderson
Interim Director

Fig. 1
Portrait of Oscar B. Jacobson, 1928
Graphite on paper , 4½ x 4¾"

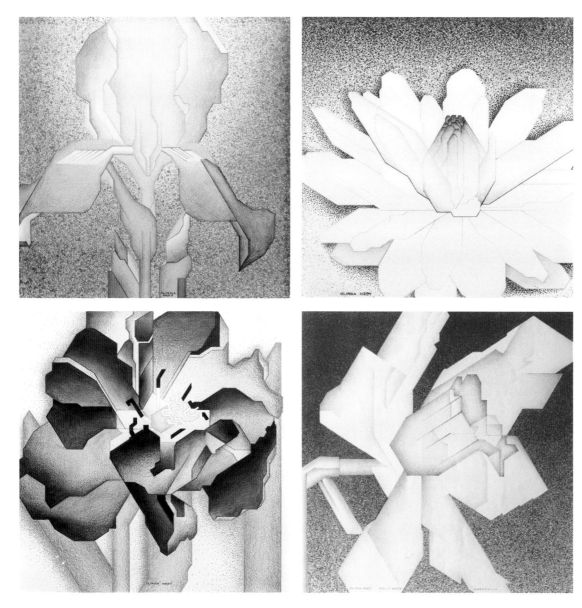

Fig. 2
Untitled, c. 1936
Watercolor and colored pencil on paper, 14½ x 11½"

Fig. 3
Untitled, c. 1937
Watercolor and colored pencil, 14½ x 11½"

Fig. 4
Untitled, c. 1937
Watercolor and colored pencil on paper, 13 x 11"

Fig. 5
Daffodil, c. 1937
Lithograph on paper 13¾ x 11¾"

Foreword

This exhibition began in late 2005 with a conversation I had with Richard Townsend, former Director and CEO of the Price Tower Art Center, and Monica Montagut, former Curator of Exhibitions and Collections at the Price Tower. I asked if the Bruce Goff material at the Price Tower contained any mention of artist Olinka Hrdy and her collaboration with Goff on the Riverside Studio in Tulsa. I had always been intrigued by Hrdy's murals for the Riverside Studio and was hoping to write an article on them. Little did I know that both Richard and Monica were contemplating a retrospective of Hrdy's career at that very moment. We began a collaboration that also included Eric M. Lee, former director of the Fred Jones Jr. Museum of Art at the University of Oklahoma, who agreed that a Hrdy retrospective would be of great scholarly interest since little had been published about her art or her life. The Fred Jones Jr. Museum of Art holds the majority of her works, a gift from Hrdy upon her return to Oklahoma in the 1960s. This catalogue is a textual companion to the exhibition and a first effort in reassessing the career of Olinka Hrdy. It is my hope that it will inspire further scholarship on this forgotten artist and designer.

This exhibition would not have been possible without the help of many. I would like to thank Eric M. Lee, Director of the Taft Museum, and Richard Townsend, Deputy Director of External Affairs at the Miami Art Museum, for their initial support of this project. I would also like to thank the staff of the Fred Jones Jr. Museum of Art for all of their hard work, especially Gail Kana Anderson, Interim Director, and Kim Moinette, Registrar. Equally, I owe a debt of gratitude to the staff of the Price Tower Art Center, particularly Scott Perkins, Curator of Exhibitions and Collections, and Kay Johnson, Registrar and Manager of the Architectural Study Center. The staff and volunteers of the Prague Historical Museum and the Lincoln County Historical Society were also instrumental in my search for the missing details of Hrdy's life. Chuck Rand, Director of the Donald C. and Elizabeth M. Dickinson Research Center at the National Cowboy Museum, gave me invaluable assistance with the taped interviews between Hrdy and collector Arthur Silberman. Other essential assistance was provided by Ilene Susan Fort, Curator of American Art at the Los Angeles County Museum of Art, Joni Kinsey, Professor of Art History at the University of Iowa, and Mary Woolever, Art and Architecture Archivist at the Ryerson and Burnham Libraries at the Art Institute of Chicago.

Mark Andrew White, Ph.D.
Guest Curator

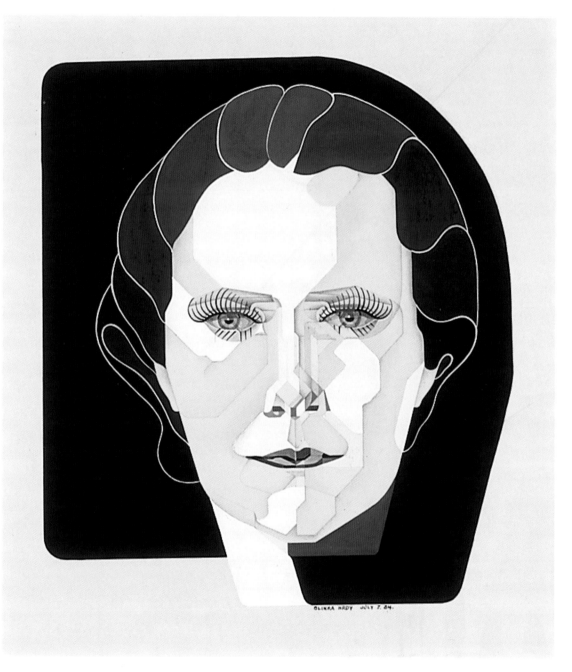

Fig. 6
Self-Portrait, 1934
Tempera on paper, 13 x 12"

Oklahoma Moderne:
The Art and Design of Olinka Hrdy

ONLY A FEW HISTORIANS OF MODERN ART AND DESIGN WOULD RECOGNIZE the name of Czech-American artist Olinka Hrdy, yet she led a prolific career, exhibiting nationally and working with distinguished architects and designers including Bruce Goff, Frank Lloyd Wright and Alfonso Iannelli. The exhibition, *Oklahoma Moderne: The Art and Design of Olinka Hrdy,* will not only demonstrate the intriguing diversity and breadth of Hrdy's career but also offer a much-needed exploration of this forgotten modernist. Hrdy proved adept at absorbing and digesting various influences from Cubism, Bauhaus abstraction, Art Deco, and even Czech embroidery. She then applied this style to easel painting, murals, textiles, and consumer products; in this way, Hrdy represents one of the few but important links between geometric abstraction and industrial design.

However, Hrdy spent much of her career at the periphery of American art and design, selling few works and never receiving significant critical attention, unlike contemporaries such as Georgia O'Keeffe and Ray Eames. Hrdy's relative anonymity in art and design history is compounded because the majority of her extant works reside at a single museum, The Fred Jones Jr. Museum of Art at the University of Oklahoma, and nearly half of her total output has been either lost or destroyed. Yet, despite her lack of influence and recognition, Hrdy's contribution is valuable because of her enthusiasm for modernist experimentation and innovation. In order to understand the significance of Hrdy's accomplishment, this essay will offer a survey of the artist's life and work from her education at the University of Oklahoma in the late 1920s to her career as a commercial and industrial designer in California in the 1940s and '50s.

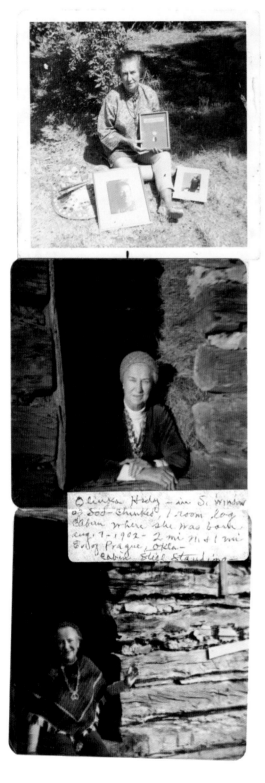

Hrdy's Early Life in Oklahoma (1902-1923)

Olinka Hrdy was born 7 August 1902 to Joseph Hrdy and Emma Benesh in the Czechoslovakian immigrant community of Prague, Oklahoma.[1] Her father Joseph Hrdy was born in Plzen, Bohemia (now the Czech Republic) and lived in Vienna before making the trek to the United States in the late 1890s. It is unclear how he met Emma or the length of their courtship, but the couple married on 30 December 1899.[2] The following October, Joseph became an American citizen, and in August 1902, the same month as Olinka's birth, he purchased both a business lot in downtown Prague and a homestead outside of town that included a sod-chinked log cabin (figs. 7A, 7B).[3] Joseph Hrdy purchased additional acreage around the home in subsequent years as his new business venture, the town's only saloon, prospered.

Olinka's mother, Emma, was also of Czech heritage, though born in Munden, Kansas. At an unknown date, Wesley Benesh, Olinka's grandfather, moved his family to the now defunct town of Dent, Indian Territory (now Oklahoma), near Prague. Emma and Joseph's marriage would last only two decades until Olinka's sixteenth birthday.[4] A few years later in 1922, Olinka left Prague with her younger brother George and her mother to farm a nearby lease just south of Prairie, Oklahoma, where they grew cotton and corn.[5] Although Olinka spent long hours working the lease, she remembered those years as some of her happiest:

> On Sundays, alone I tramped or rode through the woods at the back of the lease. Early in grade school I had gotten hold of a copy of *The Girl of the Limberlost.* I tried to be like her; it influenced my early life. I remember often riding to the edge of the swamp, butterfly net in hand, abandoning my clothes, unbraiding my long hair, and riding carefree through the woods, chasing butterflies, moths, or gathering armloads of flowers. Often after aimless riding, my dog, horse and I would ride into the creek at the edge of the fields to bathe and cool off. In the evenings, I remember distinctly the constant tom-tom beats of the Indians nearby.[6]

Fig. 7A (front)
Olinka Hrdy's Scrapbook
Olinka Hrdy is shown at Solar Hill in the top photo,1969.
She is pictured in front of her family's log cabin near Prague,
Oklahoma, 1975 in the bottom two photos.

This passage offers insight into the development of Hrdy's character and to the formation of her lifelong interest in Native American culture. Her reference to the classic children's book *A Girl of the Limberlost*, by Gene Stratton-Porter, provides some insight into Olinka's youthful activities. The book follows the life of Elnora Comstock, who frequently seeks escape in the Limberlost swamp from her dysfunctional relationship with her mother and from her family's poverty. Through her friendship with the eccentric Bird Woman, Elnora learns to collect moths and eventually pays her way through college with her hobby. The narrative has often been acclaimed for its portrayal of Elnora as a generous yet independent spirit, and her character was advanced as a role model for children and young teens. Although it is difficult to say whether Hrdy's relationship with her mother was as strained as the fictional Elnora's, Stratton-Porter's tale clearly had a profound influence on Hrdy's unconventional behavior as both a student and an artist.

Hrdy's recollection also acknowledges her awareness of and interest in Native American culture. Prague was founded on what was once the Sac and Fox (Asakiwaki and Meshkwahkihaki or Mesquakie) Agency, and Olinka seems to have been interested in tribal rituals. Her curiosity grew through her relationship with her cousin Pearle Davis, a granddaughter of the notable Alice B. Davis who was appointed the first Chairwoman of the Seminole in 1922 by President Warren G. Harding. Finally, Hrdy would become close friends with the Kiowa artists, popularly known as the "Kiowa Five," who were studying at the University of Oklahoma at the same time as Hrdy in 1926-27. These relationships seemed to influence her art little, save for subtle references in her 1929 mural entitled *Primitive Music* for Patti Adams Shriner's Riverside Music Studio in Tulsa (hereafter referred to as the Riverside Studio).[7]

During her teenage years, Hrdy earned extra money not by collecting moths as Stratton-Porter's protagonist did, but by selling embroidery. The medium has a long history among Czech women, and Olinka likely learned the tradition from her mother. Nothing of Hrdy's work seems to have survived from this period, yet the linear, angular nature of embroidery had a significant influence on her later work. She readily acknowledged her debt to embroidery, claiming that "almost everything I do [is] in line," and selecting drawings she had completed around

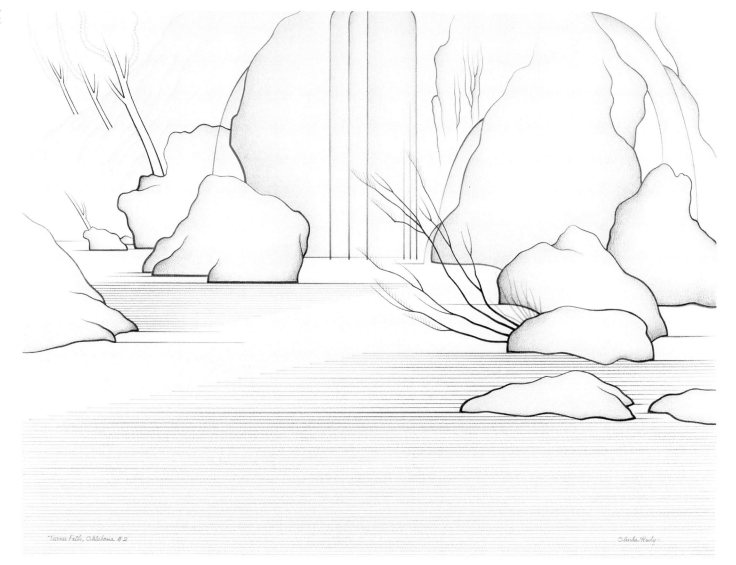

"Turner Falls, Oklahoma # 2" Olinka Hrdy

Fig. 8
Turner Falls, Oklahoma (Turner Falls No. 2), c. 1927
Colored pencil on paper, 20 x 26"

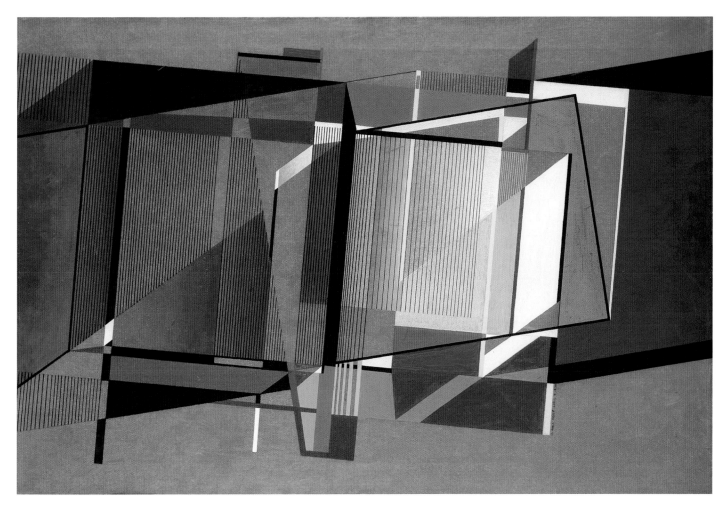

Fig. 9
Weaving, 1936
Oil on board, 24 x 36″

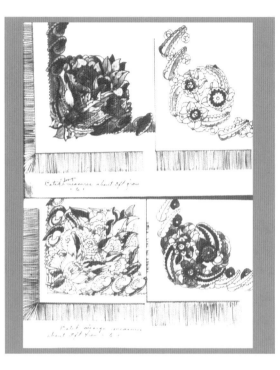

1926 of Turner Falls in central Oklahoma as evidence.[8] *Turner Falls, Oklahoma (Turner Falls No. 2)* (fig. 8; p. 14), for example, uses strong, colored contours to describe the stylized forms as an embroiderer might while contending with the warp and weft of the cloth support.

The influence of embroidery and textiles also led to the creation in 1936 of a painting appropriately titled *Weaving* (fig. 9; p. 15). As the title suggests, Hrdy wove together rectangular and rhomboidal forms with varying degrees of transparency, arriving at a finished product that bears a striking similarity to the work of Bauhaus artist László Moholy-Nagy. Hrdy clearly attained some familiarity with the ideas and techniques of international Constructivism, although it is unknown how and when, and she sought to combine her earlier facility in textiles with her maturing talent in paint.[9]

Hrdy's love for textiles also prompted her to seek further training in higher education. In the summer of 1923, she pursued a college education in Home Economics at Oklahoma A&M (now Oklahoma State University) in Stillwater. Embroidery led her to a course in textiles, but she also completed one course in art during her brief enrollment at that institution.[10] On the advice of her brother George, Olinka then transferred that fall to the University of Oklahoma in Norman where she entered what would be the most productive period of her career.

Hrdy, the University of Oklahoma, and Early Mural Painting (1923-1928)

Hrdy's first two years at OU seem to have passed with little acknowledgement or acclaim. She paid her expenses in part through the creation and sale of batik shawls, which survive only in designs (fig. 10). Batik had become a fashionable textile medium in the 1910s among women artists, and especially modernists, not only because the technique lent itself easily to the creation of abstract, organic patterns but also because of its relatively inexpensive production costs and its marketability in boutiques. As its popularity increased in the 1920s, women's journals offered tutorials, and this may be how Hrdy learned the process.[11] Her enthusiasm, along with that of the nation's, waned in the 1930s, and she seems to have abandoned the process before the end of the decade.

Fig. 10
Olinka Hrdy's Scrapbook
Untitled batik design, not dated

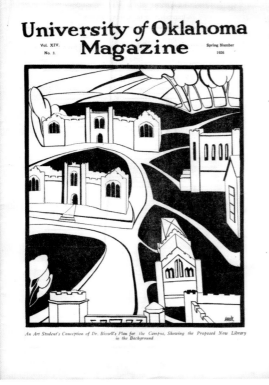

Fig. 11
"An Art Student's Conception of Dr. Bizzell's Plan for the Campus,
Showing the Proposed New Library in the Background"
University of Oklahoma Magazine 14, no. 3 (Spring 1926)

Hrdy turned her attention to illustration, and in the fall of 1925, she began contributing to the *University of Oklahoma Magazine* as a staff artist along with fellow students Ina Annette and Leonard Good (fig. 11). She also began exhibiting art work publicly by participating in a group exhibition of OU students at the YWCA in Oklahoma City in April 1926.[12]

More importantly, Hrdy began a series of drawings that year based on Oklahoma landmarks including Turner Falls and Price's Falls in the Arbuckle Mountains, the Blue River near Tishomingo, and Spavinaw Lake. Her interest in the Oklahoma landscape was likely the product of sketching trips she had made with Professor Edith Mahier's class, as an unidentified clipping in Hrdy's scrapbook indicates. Mahier's class took at least one such trip to Tishomingo, and Hrdy continued to make other such trips well past her graduation in 1928.[13] Despite Hrdy's interest in sketching en plein air, she did not always depend on firsthand observation to inform her compositions. The majority of the Turner Falls series bear only remote similarity to the actual site. Jeanne d'Ucel, wife of the art department chair Oscar Brousse Jacobson, explained this disconnection:

> [Hrdy] had never seen Turner Falls; in fact, she had never seen any water falls, she had only heard descriptions of them. Free from all the limitations that reality imposes her fancy led her to depict something far more beautiful than Turner Falls ever can be, something unreal, fairylike.[14]

Why Hrdy chose to depict a site she had never seen is unclear, but verbal descriptions surely sparked her imagination. She may have received some inspiration from photographs or from visiting Price's Falls, since her undated drawing depicts the waterfall accurately (fig. 12; p. 18). Regardless of her knowledge of the specific locales, her landscapes share a style similar to embroidery as well as an awareness of Chinese and Japanese landscape painting. Jacobson had an interest in Asian art and oversaw the Louis "Lew" Haines Wentz and Richard Gordon Matzene gift of Asian art to the university in 1936, which established the art museum at OU.[15] Hrdy shared Jacobson's enthusiasm for Asian art, as indicated by drawings such as *Turner Falls,*

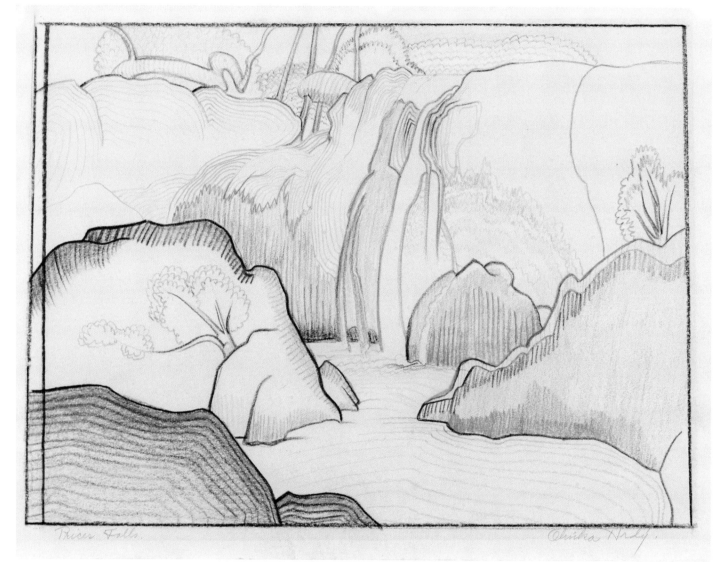

Fig. 12
Price's Falls, c. 1926
Colored pencil on paper, 9 x 12"

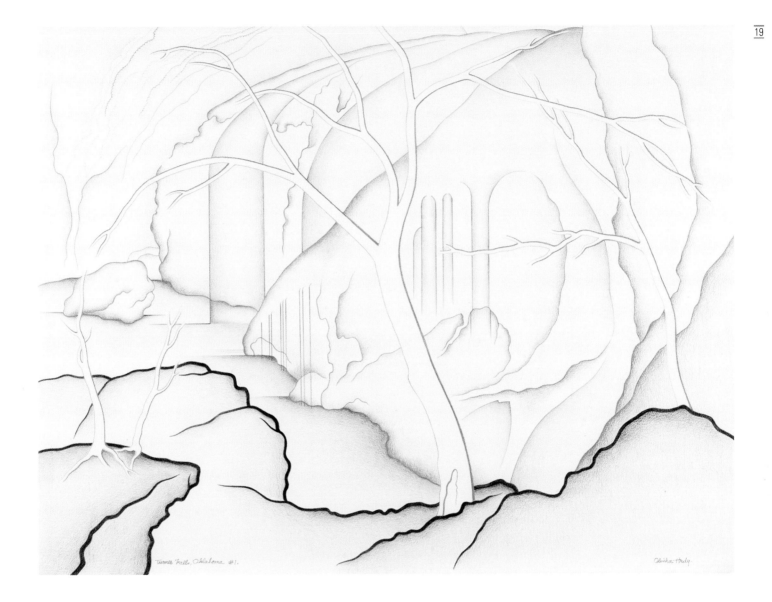

Turner Falls, Oklahoma #1.

Olinka Hrdy

Fig. 13
Turner Falls, Oklahoma (Turner Falls No. 1), c. 1927
Colored pencil on paper, 20 x 26"

Oklahoma (Turner Falls No. 1) (fig. 13; p. 19) with its emphatically linear falls reminiscent of Chinese Song landscapes.

Hrdy's landscapes hold an important place in her career, and she exhibited them continually for much of her life. In November 1928, she chose two drawings to represent her work at the Association of Oklahoma Artists exhibition at Oklahoma A&M and would send more to Frank Lloyd Wright in 1933 in hopes that they might help her earn employment at Taliesin, his school for architecture in Spring Green, Wisconsin.[16] The Turner Falls landscapes also provided the inspiration for a mural commission from Oklahoma City businessman William S. Key in the fall of 1928. Key, who established Keyokla Oil Company in 1927, had built a new residence near the state capitol, and although it is unclear how the commission came about, it is possible that Key himself approached the OU art department directly looking for a muralist to decorate his new home.[17] While the Key commission was important, it was not Hrdy's first, and she had already earned a reputation as one of the most prolific muralists in the state.

Hrdy began painting murals while still a student at OU and continued to explore the medium in the 1940s as an artist for the Federal Art Project. She attempted to harmonize her style and subject matter with the surrounding architecture: "I look at the building and I fit my mural to fit the building, to fit the architecture."[18] As such, Hrdy's murals differ aesthetically from commission to commission. Unfortunately, every mural Hrdy created in Oklahoma has since been destroyed or lost save for the two she created in 1928 for Central High School (now Oklahoma Farmers Mutual Insurance Company) in Oklahoma City, *The Development of the Mind of the Greeks* and *The Development of the Body of the Greeks*; consequently, a discussion of Hrdy's murals must depend primarily on studies and photographs.

Hrdy's initial interest in mural painting was primarily economic since she had arrived in Norman with only fifty dollars for living expenses.[19] Her finances had become so dire that Mahier arranged for her to illustrate a poem, "Maker of Dreams," in tempera for a tower office in Holmberg Hall (fig. 14). Completed on 3 June 1925, *Maker of Dreams* not only represents Hrdy's first experience with murals but also Mahier's earliest interest in fostering mural painting at OU. The latter first offered a course in mural painting in the 1926-27 academic year, which eventually resulted in the decoration of several buildings such as the Business Administration Building (Adams Hall).[20]

While *Maker of Dreams* may have been the first mural on campus, it also seems to have been the first destroyed, when a serious water leak in 1932 necessitated replastering. Reproductions indicate Hrdy composed the mural through a series of discontinuous vignettes such as drama masks, a sailing

Fig. 14
Olinka Hrdy's Scrapbook
An undated postcard of Holmberg Hall with Hrdy's annotations showing her studio, the location of *Maker of Dreams*, and the offices of her instructors

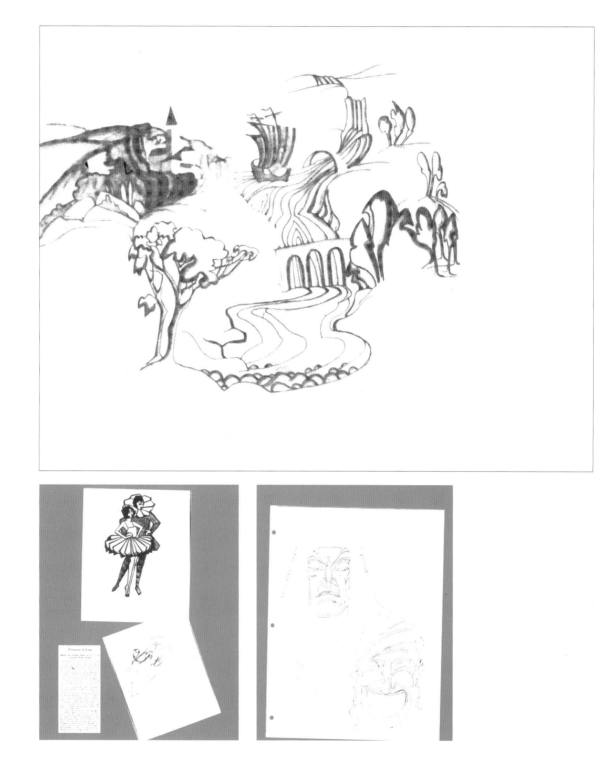

Figs. 15, 16, 17
Olinka Hrdy's Scrapbook
Untitled studies for *Maker of Dreams*, c. 1925

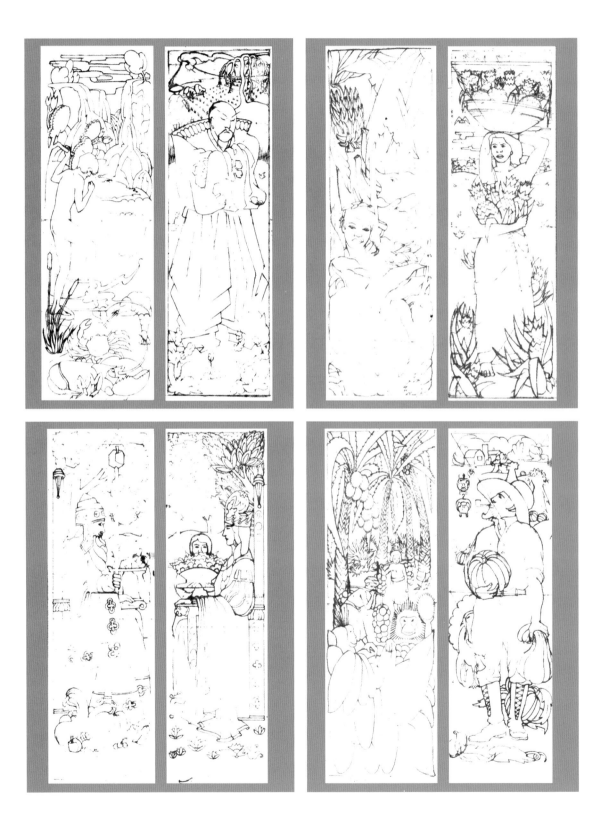

Fig. 18 (above, left)
Olinka Hrdy's Scrapbook
The Pageant of Foods
Sea Foods and *Rice*, c. 1927

Fig. 19 (above, right)
Olinka Hrdy's Scrapbook
The Pageant of Foods
Bananas and *Pineapples*, c. 1927

Fig. 20 (below, left)
Olinka Hrdy's Scrapbook
The Pageant of Foods
King of the Fruits and
Queen of the Flowers, c. 1927

Fig. 21 (below, right)
Olinka Hrdy's Scrapbook
The Pageant of Foods
Coconuts and *Pumpkins*, c. 1927

ship, a dancing couple and a fantastical landscape (figs. 15-17; p. 21). Like her landscapes, *Maker of Dreams* displayed the heavy contour and a lack of interior coloration, suggesting Hrdy's attempt to formulate a distinctive style.

Mahier, seemingly pleased with the results, helped Hrdy as much as she could. Hrdy recalled that "Edith Mahier bought my stockings, and she bought my shoes — I had no shoes … In this incarnation, I knew that she was my real mother. She took care of me."[21] The instructor also alerted Jacobson to Hrdy's situation, and through Jacobson's assistance and the intervention of university President William Bennett Bizzell, the university waived Hrdy's tuition and covered her room and board in exchange for a mural cycle for the State Dormitories for Women (now Hester and Robertson Halls). That fall, she began decorating a series of twenty doors, entitled *The Pageant of Foods*, for the dormitory cafeteria. No contract has survived, but it took Hrdy two years to complete the entire cycle, suggesting she received tuition compensation for her final two years at OU.[22]

The Pageant of Foods may have solved Hrdy's tuition and living expenses but not that of her materials. Using the "contour method" of her Turner Falls landscapes, she conserved paint by depicting forms solely through an exterior black contour and a descriptive, colorful line, such as red for apples and green for leaves; as she recalled in 1965:

> I had to furnish the paint. I couldn't afford to buy a pair of stockings
> so racked my brain and thought well how can I do this for nothing?
> So I figured out that if I used a black line around all my decorations
> and put a very brilliant line within the black line, green for the leaves
> and red for the apples an so forth, I would get a very splendorous
> effect and still not have to pay too much for the paint.[23]

The results are not readily apparent in black-and-white reproductions (figs. 18-22), but Hrdy's interest in ornamental design is evident. Preparatory drawings for *King of the Fruits* and *Queen of the Flowers*, both from 1927, demonstrate Hrdy's interest in pattern and stylized, organic forms such as the sinuously curving squash in the former or the almond-shaped leaves in the latter. Both images also hint at the extent of Hrdy's visual vocabulary, particularly in the royal vestments, which borrow from both European and Central Asian influences.

Some images, unfortunately, also indicate that Hrdy was given to racial stereotypes with the slit-eyed Chinese nobleman in *Rice* or the blundering African American caught stealing gourds in *Watermelon*. While the merit of some of Hrdy's sources is questionable, it is clear that she was far from the novice that she claimed to be later in life. Declaring that when she began the

Fig. 22 (above)
Olinka Hrdy's Scrapbook
The Pageant of Foods
Watermelons and *Fish*, c. 1927

Fig. 23
Undated postcard of The Copper Kettle, Norman, Oklahoma

Fig. 24
Mural section from The Copper Kettle, reproduced in Jeanne d'Ucel,
"Olinka Hrdy: Her Genius Wins Applause in the Art World Through
Modern Masterpieces," *Sooner Magazine*, vol. 1, no. 10 (July 1929): 344

cycle she had not yet enrolled in the art department and "didn't know a thing about design," not only contradicts her work, which demonstrates a knowledge of aesthetic fundamentals as well as artistic and popular iconography, but also her academic transcript, which proves that she had been taking art classes since 1923 at both OU and Oklahoma A&M.

The Pageant of Foods was not the only mural Hrdy completed for Hester Hall. In the winter of 1927, she painted a 5 x 5' mural of three nude figures in her dorm room, 106 Hester Hall. Uncharacteristically, Hrdy had not obtained permission for this mural and was nearly expelled for it; however, her intent was not to antagonize the administration but to frighten away potential roommates. Jeanne d'Ucel did not mention the mural as the culprit but remembered that "whenever prospects were around Olinka saw to it that the appearance of her room scared them away. She succeeded."[24]

While Hrdy continued work on *The Pageant of Foods*, she began another commission for the local restaurant, The Copper Kettle, owned by Hartwell Hill. The structure, built in a Tudor style, prompted Hrdy to adopt a "medieval" style similar to manuscripts and tapestries (figs. 24-25). Since the restaurant was popular among students, Hrdy chose a satirical theme of college life set in the medieval period.[25] Approximately 250 figures, some life-sized, filled the extensive composition, which was 32 x 7' and included portraits of fellow students and professors, such as Bizzell, Jacobson, and Mahier, engaged in a variety of activities. In one section, irate students burn a language professor at the stake in an ad hoc inquisition, while another depicts a "modern" coed having her hair bobbed in the midst of her scandalized colleagues (fig. 25).

A self-portrait of Olinka, in nun's costume, is evident in a reproduction of a drawing since lost (fig. 26). This self-portrait as a sister of the cloth was somewhat ironic, considering that Hrdy had the "controversial" bobbed hair depicted in her mural. She actually was of Bohemian heritage, but she also sometimes displayed what Americans might have considered to be "bohemian" characteristics by painting nude figures on her dorm room wall and remaining unmarried for much of her life.[26] In this regard, Hrdy also embraced the concept of the "New Woman," a term often used by suffragists in the early twentieth century to describe women who sought higher education, financial and sexual independence, and a voice in social and political matters.[27] A series of photographs produced in 1931 reveal that Hrdy, clad in a long silk gown decorated by curving lines reminiscent of Art Nouveau patterning, also cultivated an image of the "New Woman" as expressed by popular fashion magazines (fig. 28; p. 27). The techniques and trappings of the photographs follow those of Edward Steichen's fashion photography for Condé Nast,

which was characterized by stark lighting contrasts, free of backlighting, and an absence of background. Barbara Haskell has argued that Steichen's photographs sought "a polished and glamorous look that accorded with the self-reliant femininity of the new woman."[28] The photographs of Hrdy suggest an introspective woman who consciously constructed her own public image in both fashion and behavior.

As part of her "New Woman" persona, Hrdy achieved financial independence, although often out of necessity rather than choice. Her parents' lack of financial support forced her to seek out multiple commissions during the late 1920s to secure some stability, but this also brought her acclaim. Hrdy finished the Copper Kettle murals in May 1928 weeks before her graduation and received numerous accolades for her work at OU, including a solo exhibition at the Fine Arts Building and the award of the Letzeiser Gold Medal, one of the University's highest honors. *The Pageant of Food* and the Copper Kettle murals also garnered her two subsequent commissions in Oklahoma City for the aforementioned William S. Key residence and Central High School in Oklahoma City. Hrdy completed the Key mural by mid-October and quickly began the Central High School commission, planning two murals entitled *The Development of the Mind of the Greeks* and *The Development of the Body of the Greeks*, 1928, for the atrium of the Neo-Classical building (fig. 27; p. 26). Adopting the style of ancient Greek vase painting for both murals, Hrdy emphasized painting and sculpture as the ideal form of mental exercise, with a setting in front of the Acropolis in Athens. *Development of the Body* depicts athletics such as discus and archery as a means of perfecting the body, and in a nod to her alma mater, she recruited Tom Churchill, OU All-American athlete and Olympic decathlete, to pose for her Greek Olympians.[29]

The Central High School murals were Hrdy's last in Oklahoma City. She moved to Tulsa shortly after their completion at the request of architect Bruce Goff, who asked her to design an elaborate mural cycle for his recent commission for a music studio on Riverside Drive.

Hrdy, Bruce Goff, and the Riverside Studio (1929)

Hrdy's extensive experience with mural painting had brought her respect and acclaim from both instructors and fellow artists, and it soon resulted in one of the most significant commissions of her career. During the completion of *The Pageant of Foods*, architect Bruce Goff and his wife, Evelyn Hall, happened upon the murals while on a business trip to OU. Goff was affiliated with the firm Rush, Endacott, & Rush in Tulsa, where he made partner in 1929. He instantly admired Hrdy's work and convinced her to move to Tulsa in 1929 to

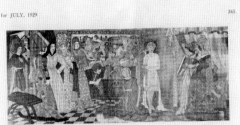

THE LADIES OF THE ROUND TABLE ARE SHOCKED BY MISS MODERN'S BREVITIES

DETAIL FROM A COPPER KETTLE MURAL

Fig. 25
Mural section from The Copper Kettle, reproduced in Jeanne d'Ucel, "Olinka Hrdy: Her Genius Wins Applause in the Art World Through Modern Masterpieces," *Sooner Magazine*, vol. 1, no. 10 (July 1929): 345

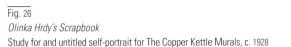

Fig. 26
Olinka Hrdy's Scrapbook
Study for and untitled self-portrait for The Copper Kettle Murals, c. 1928

Fig. 27
The Development of the Mind of the Greeks
(Mural Design for Central High School, Oklahoma City), 1928
Pen, ink and watercolor on paper, 15 x 18"

design a mural cycle for pianist and music teacher Patti Adams Shriner, who had commissioned Goff to design a recital hall and home two years earlier. Goff had significant influence in the commission, and the resulting structure, the Riverside Studio, united his interests in the architecture of Erich Mendelsohn, especially the Einsteinturm or Einstein Tower, 1919-24, and his growing familiarity with the International Style of Le Corbusier, such as the Villa Savoye, 1929-31. His enthusiasm for modernist architecture and painting, which he also practiced, prompted Hrdy to abandon her representational style; as she explained: "he was so modern that I had to make a turn around."[30] Her aesthetic response not only represents a significant deviation from her previous mural styles but also a striking fusion of Art Deco design and modernist abstraction.

To understand Hrdy's "turn around," it is necessary to examine both Goff's influence on Hrdy and his intention for the Riverside Studio to unify the arts — specifically architecture, painting, sculpture, and music. Goff was born in Alton, Kansas, in 1904 and arrived in Tulsa with his family in 1915. At the age of twelve, he apprenticed at Rush, Endacott, & Rush and joined the firm formally after his graduation from Tulsa High School in 1922. Edwin Arthur Rush introduced Goff to the work of Frank Lloyd Wright during this time, and the younger architect readily absorbed the strong horizontality and open floor plans that characterized Wright's Prairie School designs.[31]

Goff, however, refused to settle on a single style and soon began to ingest influences from Art Deco and the International Style movements. Goff scholar David DeLong has suggested that a familiarity with Le Corbusier's *Vers une architecture*, 1923, may have led to Goff's experimentation with the angular geometry of the International Style and his emphasis on structural form in the Riverside Studio, eliminating applied ornament and covering the façade in white painted stucco. He organized the studio's black glass windows along a series of opposing diagonals that when viewed askew emulate ascending or descending musical scales, as shown in an elevation study of the studio from 1927 (fig. 31; p. 28). The arrangement of the windows also refers to Goff's fascination with player piano rolls, which he both collected and created as a means of investigating correlations between visual and aural stimuli. Hrdy would offer homage to this interest in the perforated pinnacles along the right side of the *Piano Music* mural (fig. 35; p. 30).[32]

Goff's desire to associate architecture with music was not merely the result of the commission but a familiarity with the theories of Claude Bragdon, whose *Architecture and Democracy*, 1918, not only emphasizes the importance of geometry in architecture but also promoted the idea of architecture as "frozen music." Seeking correspondences between the disparate arts, Bragdon contended that architecture, like music, unfolded in time. Goff signaled his

Fig. 28
Unknown Artist
Olinka Hrdy, 1931
Gelatin silver print, 10 x 8"

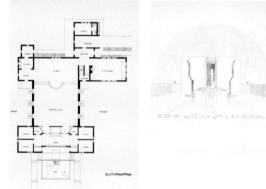

intentions to explore Bragdon's theories in the Riverside Studio in a letter to Alfonso Iannelli, whom Goff had asked to design an exterior fountain for the structure: "It is a beautiful opportunity to express the intimate relation of music and architecture, in which I am a firm believer." Iannelli called Goff's idea "frozen music" suggesting that Goff's interest was not merely in window placement but perhaps in the floor plan itself (fig. 30).[33]

Iannelli assisted in this endeavor by designing *The Waterfall*, a fountain composed of black, orange, and white marble with chromium cups that emitted musical sounds as water flowed into them (fig. 29).[34] Only Goff's elevation study exists, so it is difficult to gauge the visual and aural impact the fountain had on the structure and site. Both the fountain and Iannelli must have made a favorable impression upon Hrdy, who would maintain contact with the sculptor for the next decade and visit his Chicago studio in 1933.

Hrdy's murals were intended to unify Goff's vision for the Riverside Studio, prompting her to choose music and the unification of the arts as the theme for her cycle. Since the murals no longer exist, it is difficult to say how the cycle harmonized with the interior's aesthetic and color scheme, but her surviving watercolor studies and period photographs offer some indication. Architect and artist integrated the mural cycle into the interior by extending each canvas panel from the wall onto the ceiling, folding them at a ninety-degree angle (fig. 41A; p. 32). Hrdy's intense coloration probably harmonized with Goff's interior finishes, including maple floors stained a dark blue, walls paneled in a grayish green Japanese wood, a ceiling surfaced with aluminum leaf, and a green marble fireplace adorned with black glass tiles.

Hrdy's primary objective, however, was to emphasize relationships between the arts, so she began her cycle with *Symphony of the Arts (Painting, Architecture, Music, and Dance)* (fig. 32). Located in the foyer between the two portals to the recital hall, *Symphony of the Arts*, as the thematic introduction to the cycle, was larger than the remainder located on the other side of the portal. It depicts an abstracted feminine figure dancing in an architectonic structure. The central forms reference both Goff and Evelyn Hall; the rhomboidal form bears a similarity to the tapering structure of his original design for the Riverside Studio, and the dancing figure, a portrait of Hall, was based in part on a series of forty-six watercolors of her that Hrdy completed in 1929.[35] In a mandorla that surrounds the architectonic structure, musical notations such as fortes and naturals course upwards towards transmitting waves at the pinnacle. Hrdy unifies her own medium of painting with that of architecture, dance, and music through the painted mural itself and through the inclusion of both the primary and secondary colors that flank the architectonic structure in a series of perspectival bricks.

Fig. 29, 30, 31
Bruce Alonzo Goff (U.S. 1904-1982)

Fig. 29 (above)
Shriner, Patti Adams House and Studio, number 2, Tulsa, Oklahoma:
Perspective Elevation of View Toward Public Entrance, Circular
Window Scheme, 1928
Van Dyke sepia print

Fig. 30 (below, left)
Shriner, Patti Adams House and Studio, number 2, Tulsa, Oklahoma:
Presentation Plan: "Patti Adams School of Music, Studio & Home", 1928
Ink and graphite on white tracing paper, 33 x 24 ½"

Fig. 31 (below, right)
Shriner, Patti Adams House and Studio, number 2, Tulsa, Oklahoma:
Showing Preliminary Facade Treatment, 1928
Graphite and colored pencil on laid paper, 21 x 16¾"

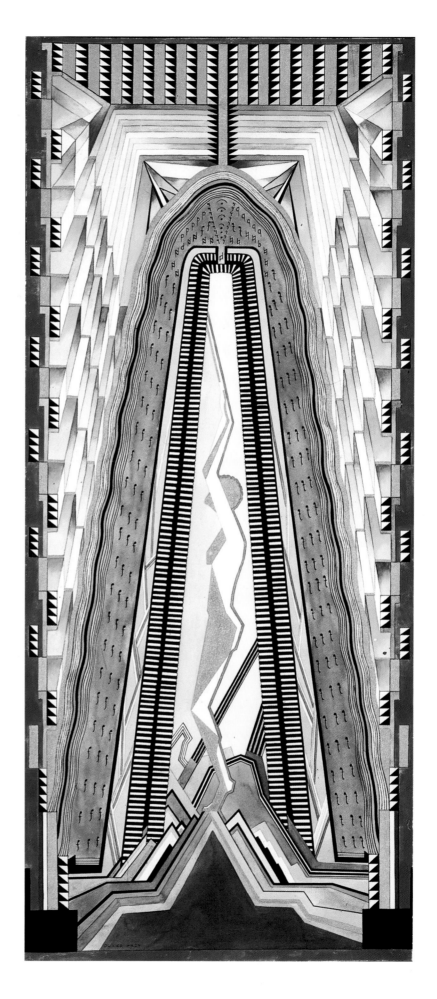

Fig. 32
Study for Tulsa Riverside Studio Murals:
Symphony of the Arts, 1928-29
Watercolor on paper, 23¾ x 10½"

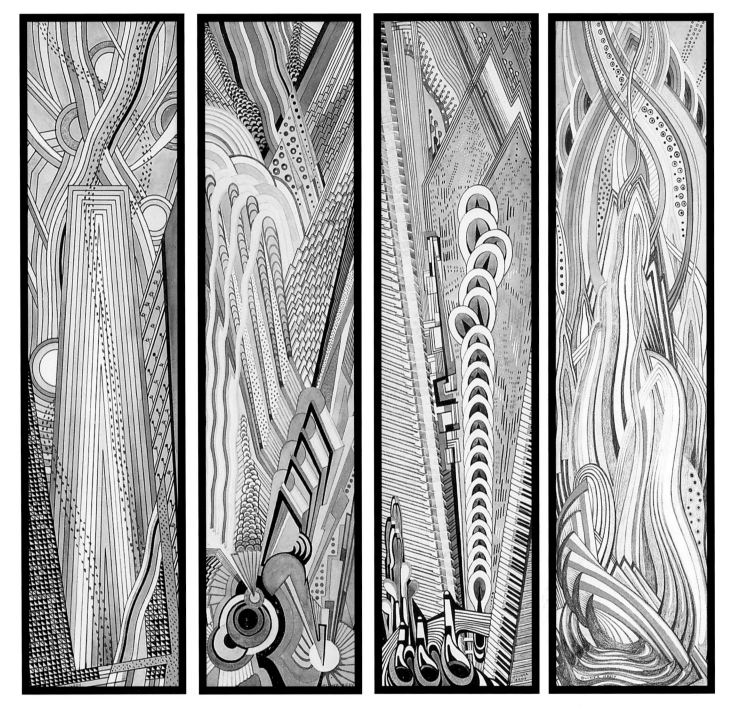

Figs. 33-40 (all panels)
Studies for Tulsa Riverside Studio Murals, 1928-29
Watercolor on paper, 18 x 4½"

Fig. 33
Modern American Music

Fig. 34
Vocal Music

Fig. 35
Piano Music

Fig. 36
String Music

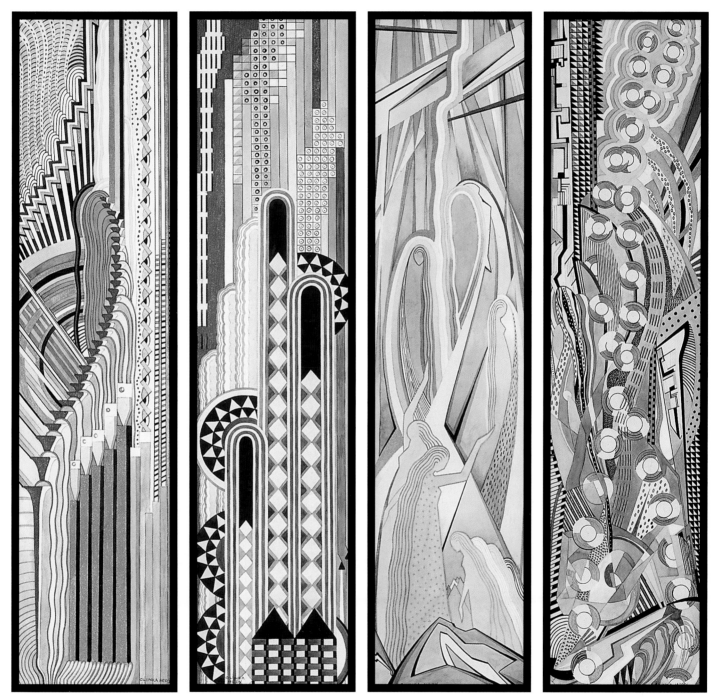

Fig. 37
Orchestra Music

Fig. 38
Primitive Music

Fig. 39
Choral Music

Fig. 40
Music of the Future

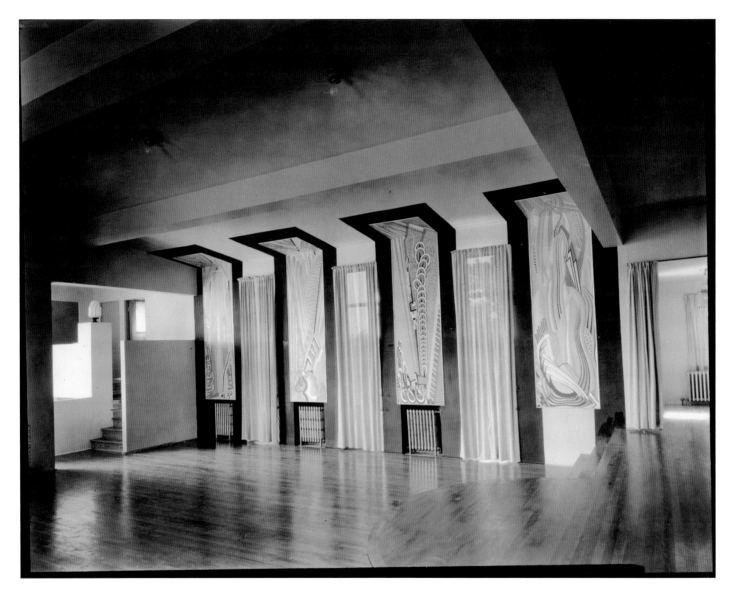

Fig. 41A
Paul Stithem
Photograph of the recital hall of the Riverside Studio, c. 1929.
Bruce Goff Papers, Art Institute of Chicago

Symphony of the Arts conveys an emphatic verticality not only through the shape of the support but also through the upward vibration of all of the visual elements, a theme Hrdy carried through the rest of the cycle. This suggests a desire for uplift or transcendence which, according to Webster's, indicates an aspiration to "overstep; exceed," and "to go beyond the limits of" some limitation.[36] Such imagery indicates further the influence of Goff, whose distaste for representational art prompted Hrdy to embrace abstraction as a form of artistic and spiritual liberation. In 1931, Goff penned "Pure and Representative Art" for the first and only issue of *TULSART* in which he deemed representational art a form of "slavery." Describing the freedom that "pure" or non-representational art offered the artist, Goff claimed:

> now he is free to express himself naturally and simply in pure art
> forms, because these forms are free from representation, yet he is
> afraid – in spite of himself, man grows steadily to the ideal of
> ABSTRACTION.[37]

Hrdy may have been unable or unwilling to abandon representation entirely, as evinced in the dancing form in *Symphony of the Arts* or the female choir in *Choral Music*, but his influence would prompt her to forsake representation, albeit briefly, in the 1930s.

Symphony of the Arts established the theme, format, and aesthetic for the remaining eight murals in the recital hall, which offered a survey of various musical genres: *Modern American, Vocal, Piano, String, Orchestra, Primitive, Choral* and *Music of the Future*. Although the recital hall murals were smaller in scale than *Symphony of the Arts*, each continued the verticality and depicted their given subject through an abstract language derived largely from Art Deco and European modernism. Hrdy's exposure to Art Deco came not only through Goff's knowledge of the style but also from contemporary design she found in magazines, and perhaps more from the downtown architecture in Tulsa. She scoured popular magazines such as *Vogue* and *Harper's Bazaar* in search of useful design elements. The premier issue of *Art in Architecture* was particularly important not only for its examples of Art Deco motifs but also for an article on Rockwell Kent, whose stylized illustrations from the late 1920s and early 1930s attracted Hrdy.[38] Apart from such magazines, she could have seen numerous examples in downtown Tulsa, such as Francis Barry Byrne's 1926 Christ the King Church, Goff's 1927 Tulsa Building, or his contributions to the 1929 Boston Avenue Methodist Church.[39] Hrdy's exposure to Art Deco is readily apparent in the

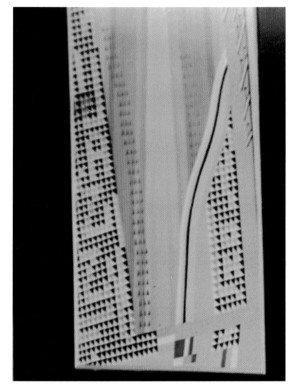

Fig. 41B
Paul Stithem
Detail from the left panel of Fig. 41A
"Jazz" is spelled vertically on *Modern American Music*

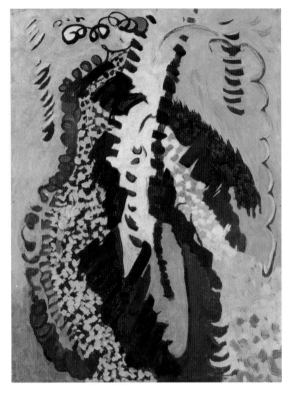

murals themselves judging by her use of familiar elements such as the sunburst in *Primitive Music* (fig. 38; p. 31); the stepped forms in *Piano* (fig. 35; p. 30), *Orchestra* (fig. 37; p. 31) and *Primitive Music*; chevrons in *Modern American Music* (fig. 33; p. 30); or zigzags in *Piano Music* (fig. 35; p. 30).

Although David DeLong calls Hrdy's use of modern design "naïve," the artist employed the language of Art Deco without mere imitation.[40] The compositions of the murals prove a knowledge of modernism, especially Cubism, and Hrdy would have learned of modernist styles from both Goff and Jacobson, the latter of which published an article on Cubism, Futurism, and Synchromism in 1924.[41] Her placement of forms relies on both the jarring juxtapositions of Cubist faceting and the diversity of pattern found in Cubist collage. A photograph from a costume party taken at some point during her Tulsa years confirms that she had more than a just a passing familiarity with Cubism. Her costume, made from painted oil cloth, is an impressive depiction of a Cubist figure similar to Jean Metzinger or Juan Gris (fig. 43).

A familiarity with Cubism may not be sufficient to prove the sophistication of the Riverside Studio murals, but Hrdy's use of synaesthesia lends additional credence to the complexity of her cycle. Synaesthesia is commonly defined as the influence of one sense upon another, and Hrdy linked forms and colors to distinct sounds.[42] For instance, she equated the numerous rounded forms in *Vocal Music* (fig. 34; p. 30) with staccatos and the biomorphic forms in the lower left of *Piano Music* with the aural vibration of a hammer striking the strings. Hrdy also indicated, although ambiguously, that she and Goff had discussed associations between color and music in preparation for the Riverside Studio cycle, and Jacobson's knowledge of Synchromism, which equated color with music, certainly would have been imparted to Hrdy.[43] Additionally, one anonymous reviewer observed that "'grace notes' of brilliant red, steely blues and expanses of warm gray seem to be the very tone-colors fixed in a fleeting moment." The same reviewer also associated the murals with the music of Claude Debussy, Igor Stravinsky, and Arnold Schönberg, composers often celebrated by modernist painters.[44] Finally, the ascending quality of Hrdy's forms, like those of the record albums depicted in *Music of the Future*, also bear some similarity to notable examples of synaesthetic imagery such as Arthur Dove's 1927 interpretation of George Gershwin's "I'll Build A Stairway to Paradise" (fig. 42).

Hrdy's equivalency between music and visual forms even took a semantic direction after a disagreement with Shriner. Goff recalled in 1980 that Shriner strongly objected to the intensity of Hrdy's palette, claiming that every color reminded her of a negative emotion.[45] Shriner also disliked jazz, so Hrdy, perhaps in retribution for the former's belligerent behavior, encoded the word "JAZZ" among the grid of triangles in the lower left corner of *Modern American Music* (figs. 41A, 41B; pp. 32, 33).

Fig. 42
Arthur Dove (U.S. 1880-1946)
George Gershwin - I'll Build a Stairway to Paradise, 1927
Ink, metallic paint, and oil on paperboard, 20 x 15"
Museum of Fine Arts Boston

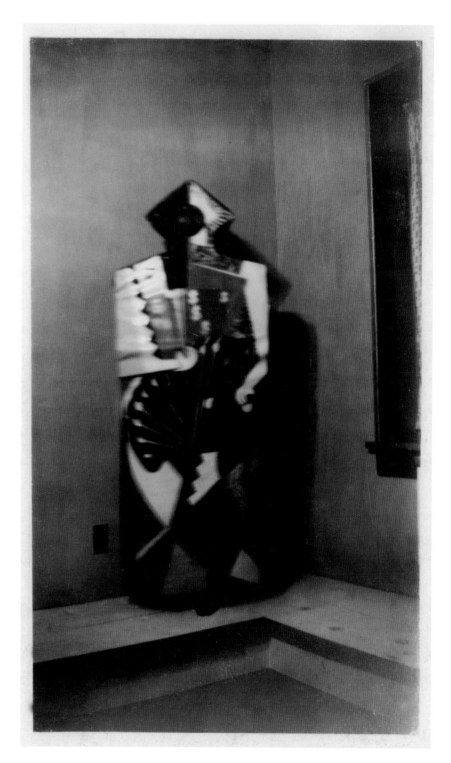

Fig. 43
Hrdy in an oilcloth costume, c. 1929.
Goff Papers, Art Institute of Chicago

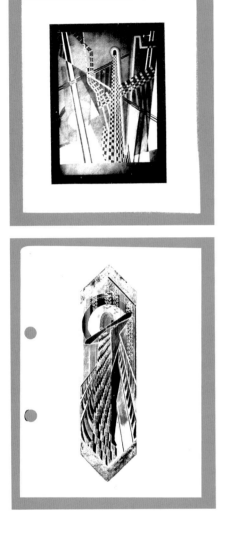

Hrdy completed the Riverside murals on 3 May 1929, and Goff wasted no time in praising Hrdy's murals as "among the first adventures in abstract decoration in America."[46] Goff may have overstated the importance of the murals, but they do predate the majority of abstract murals by about seven years. Nevertheless, Goff's enthusiasm for Hrdy's work would lead to further collaboration. For instance, Goff instilled in the artist an interest in music composition, and at least on one occasion she helped compose several musical scores with Goff and mutual friend Ernest Brooks, a musician and later instructor of music at Taliesin.[47]

Hrdy in Tulsa (1929-1931)

Although Hrdy lived in Tulsa for only two years before departing for New York City in 1931, the Riverside Studio murals initiated a period of intense activity in her career. Even before the completion of the Riverside Studio murals, Iannelli sought further collaboration with Hrdy, and in March 1929, he arranged an exhibition of all forty-six watercolors of Evelyn Hall at the Art Institute of Chicago.[48] Most of these watercolors have been lost, but *Fire Figure*, c. 1929, (fig. 46) remains and offers an indication of the dancing feminine subject that dominated the series.

Hrdy followed the Art Institute exhibition with a showing at the McGee Art Shop in downtown Tulsa in November 1929. The checklist offers insights into Hrdy's creative activities as it not only included the Turner Falls drawings and Evelyn Hall watercolors but also works that indicate the influence of Goff, such as *Abstract Mechanical Painting, Mechanical Rhythm*, and her homage to the local roller coaster, *Riding the Zingo* or *The Zingo Ride* (fig. 44).[49] The use of "abstract" and "mechanical" in her titles suggests a lack of narrative or representation in favor of an emphasis on formal elements, such as taut lines and flat planes. Hrdy's familiarity with Cubist themes may have also led her to embrace mechanistic imagery in the manner of the French artist Fernand Leger or possibly the American Louis Lozowick. A *Tulsa Daily World* article from the time period confirmed Hrdy's fascination with mechanistic and industrial forms:

> Her present enthusiasm is for the mechanistic marvels of construction. She thinks that machinery is as beautiful in its strength and simple lines as a pastoral landscape or handsome woman may be. She constantly amazes her companions by exclaiming 'Beautiful!' at the sight of a street dredge or smoothly modulated engine.[50]

Fig. 44
Olinka Hrdy's Scrapbook
Riding the Zingo or *The Zingo Ride*, c. 1929
(dimensions and location unknown)

Fig. 45
Olinka Hrdy's Scrapbook
Untitled work for Dalton Lain, c. 1929
(dimensions and location unknown)

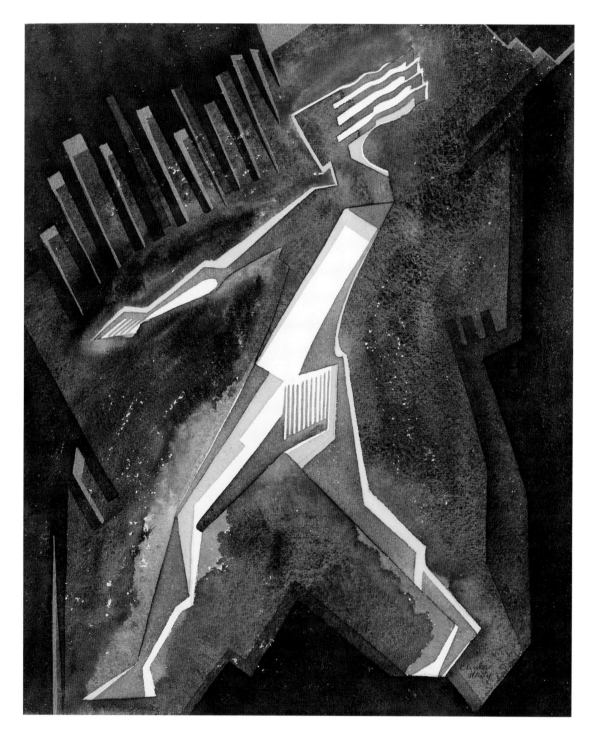

Fig. 46
Fire Figure, c. 1929
Watercolor on paper, 12 x 10"

Fig. 47A
Untitled (Flatware Competition Entry for Holmes and Edwards), c. 1929
Ink and graphite on paper, each panel: 11 x 5¾"

Fig. 47B
Untitled (Flatware Competition Entry for Holmes and Edwards), c. 1929
Ink and graphite on paper, each panel: 11 x 5¾"

The McGee exhibition also featured *Modern Refinery at Night*, a tempera painting that likely began as a mural study for Goff's Tulsa Club. Hrdy never seems to have completed the mural but preparations are confirmed by both the reference to the painting and an *Oklahoma Daily* article from 17 January 1929.[51]

Even if the Tulsa Club commission fell through, Hrdy found other opportunities. By August, she had created an abstracted figure and decorative design for Tulsa resident Dalton Lain (fig. 45; p. 36). Etched on a mirror above his fireplace, the object is now lost, though a surviving photograph indicates Hrdy's continuation of some of the motifs from her Riverside Studio murals, specifically in the decorative cloth that envelops the nude figure. That same year she also entered a flatware competition sponsored by Holmes and Edwards and juried by Charles Dana Gibson (figs. 47A, 47B). Though not chosen for final production, her proposal survives as proof of her continuing interest in Art Deco.

Early in 1930, Goff collaborated again with Hrdy in his redesign of the interior of the Tulsa Convention Hall, a relatively austere structure once described as "the good old barn" and "Tulsa's ugly duckling," of which the city commission had decided to modernize the interior.[52] Endacott, Rush & Goff received the commission, and Goff designed forty-five lighting fixtures of green and frosted glass and redecorated the ceiling in a geometric pattern of gold and green (figs. 48A, 48B). He asked Hrdy to complement his interior design with both a new image for the fifty-foot-long stage curtain and an entranceway mural. Using the existing asbestos stage curtain as the support for her geometric construction, Hrdy seems to have been far more conscious of international developments in abstraction (fig. 49; p. 40). Her interest in mechanistic imagery during this time period suggests familiarity with Constructivism, Bauhaus abstraction, or Precisionism, whose principles were easily available through art journals or the publicized efforts of Katherine Dreier's Société Anonyme in New York City. Hrdy's checkered grids, rippling verticals, and colorful horizontal bands compare closely to either the paintings of Josef Albers or to Bauhaus graphics, such as Joost Schmidt's well-known 1923 poster for the Bauhaus exhibition in Weimar; however, a closer comparison would seem to be the tapestries of Gunta Stölzl, a *Jungmeister* (junior master) at the Bauhaus who was appointed head of the Weaving Workshop in 1927. Unfortunately, Stölzl's work was relatively unknown in the U.S. before 1930, so it is doubtful that Hrdy could have seen the former's textiles in illustration.[53]

Regardless of specific influences, Hrdy clearly intended her curtain design to depict machine-age imagery as suggested by her characterization of the entranceway mural, which is no longer extant. She described the 7 x 11' painting as a "Modern abstract mural – mechanical in composition, painted on gold wall. Composition: a huge circle seven feet in diameter with bands of green

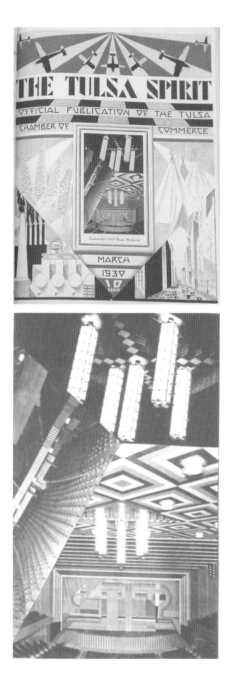

Fig. 48A
The Tulsa Spirit
Official Publication of the Tulsa Chamber of Commerce (Convention Hall Goes Moderne), March 1930

Fig. 48B
The Tulsa Spirit (detail)

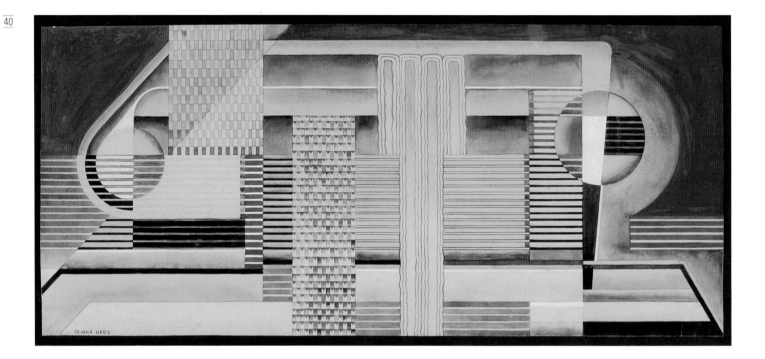

Fig. 49
Cartoon for Tulsa Convention Hall Curtain, c. 1930
Tempera on paper, 11 x 25"

and black, cutting the center, giving the composition balance."[54] From this description, the mural was perhaps similar to the circular elements at each end of the stage curtain's design and was likely intended to harmonize formally with the curtain in the hall.

The Convention Hall designs further illustrate Hrdy's understanding of abstraction and helped to solidify her position as a modernist. After completing the Convention Hall project on 7 March 1930, she appears to have experienced a brief lull in activity, and while it is doubtful that Hrdy produced no new work during this time, her personal records provide little insight. She did exhibit the studies for the Riverside Studio murals at the Denver Art Museum in June 1931, and that December, she produced two abstract murals for the Charles Bland Dance Studio at Harvard and 15th Street.[55] Despite Hrdy's growing reputation in Oklahoma and a seeming wealth of opportunities, she found it difficult to ignore the allure of New York City, and by the end of 1931 she had left Oklahoma to further her education and search for employment.

Hrdy in New York City (1931-1933)

Hrdy's first destination in New York City was the Master Institute of the Roerich Museum, where she hoped to meet the founder, Russian artist Nicholai Roerich. It is unclear how Hrdy came to know Roerich's work, but she claimed to have seen in her youth an issue of *National Geographic* that included Roerich's work; however, Roerich did not appear in the journal in either the 1910s or 1920s. It is more likely that she learned of the Russian from her friend Richard Gordon Matzene, a British photographer who had a studio in Ponca City, Oklahoma, and who had spent much of the 1920s in India, Nepal and China, approximately the same time that Roerich toured those countries. Apart from Matzene's possible familiarity with Roerich, the Russian artist had already earned notoriety in the U.S. for his stage designs, paintings, and promotion of Buddhism and Theosophy. Hrdy would embrace Zen Buddhism later in life and had been impressed by Matzene's tales of Asia, so it is possible that her interest in Roerich was not limited to art instruction.[56]

Regardless of their introduction, Hrdy discovered the Master Institute and Roerich by some means, and with added support from a $1200 scholarship, she enrolled in classes under Howard Giles, the Institute's primary instructor.[57] Giles was an artist and illustrator who had studied at the Art Student's League. Little is known of Hrdy's study under Giles, but she did credit him with her introduction to a composition system, Dynamic Symmetry.

Invented by Jay Hambidge in 1917, Dynamic Symmetry focuses primarily on the geometric manipulation of rectangles and the illusionistic tension of diagonal lines. Hambidge, through his extensive examination of the Parthenon, theorized

that the fifth-century Greeks possessed a measurement system based on the diagonals and square roots of rectangles (units of area), rather than the fixed, standard measurements of length used currently. The author considered the root five rectangle to be the ideal expression of both natural order and Dynamic Symmetry because it resisted division into equal parts, unlike the square or other modern units of measurement. A root five rectangle may be diagrammed as any rectangle in which a square constructed on the longer side occupies five times the area of a square constructed on the smaller side, creating a ratio of 1:1.618.[58] The compositional application of Dynamic Symmetry centers primarily on a property Hambidge called "the rectangle of the whirling squares," in which the artist constructs a logarithmic spiral of increasingly smaller squares within the rectangular frame of design. The resulting linear constructions provide a diagram by which the artist might plan out the composition (fig. 50).

Hrdy wasted little time in exploring the possibilities of Dynamic Symmetry. She began a series of portraits in 1932 that emphasized the geometric foundation of the compositional system. For instance, her portraits of *Jack Huston*, 1932, (fig. 51) and *Phil McMann*, early 1930s, (fig. 53; p. 45) demonstrate a linearity and angularity derived from the underlying geometric framework. The portraits also possess an intense coloration and decorative patterning reminiscent of her Tulsa murals. *Phil McMann*, a portrait of a Tulsa friend, introduced another variation through the illusionistic suggestion of glass planes, which may mimic the glass chandeliers Goff created for the Convention Hall.[59] The most experimental, however, was her portrait of *Mildred Maxey*, 1932, (fig. 52; p. 44) which is composed partly of repetitive typewritten letters and numerals. Maxey was a thespian Hrdy had met in Tulsa, and the text, when read and transcribed, offers wry insight into Maxey's personality:

I AM MILDRED MAXEY

STAGE

LIGHTS

SOUND

MILLIONS

WAITING

STAGE

WHEN I AM OLD ILL BE HAPPY

WHEN I HAVE 3 4 AND 5 hUSBANDS

Since little is known of Maxey's life or her relationship to Hrdy, it is difficult to interpret the meaning behind the text, yet a profile on Maxey from the Tulsa Central High School Class of 1925 Annual may shed some light on the work and

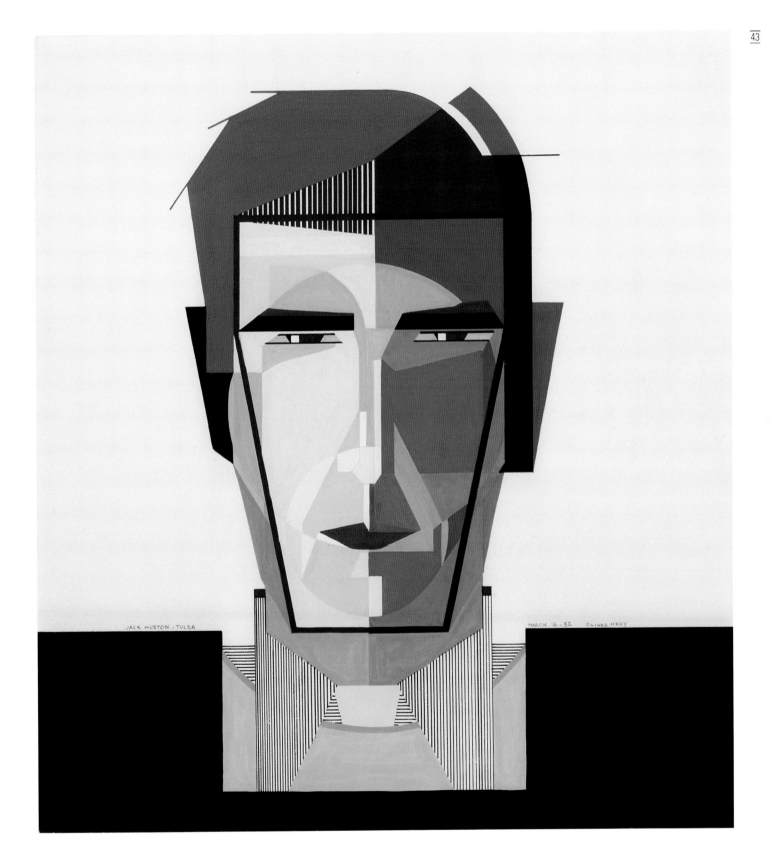

Fig. 51
Jack Huston, 1932
Tempera on paper, 13 x 12″

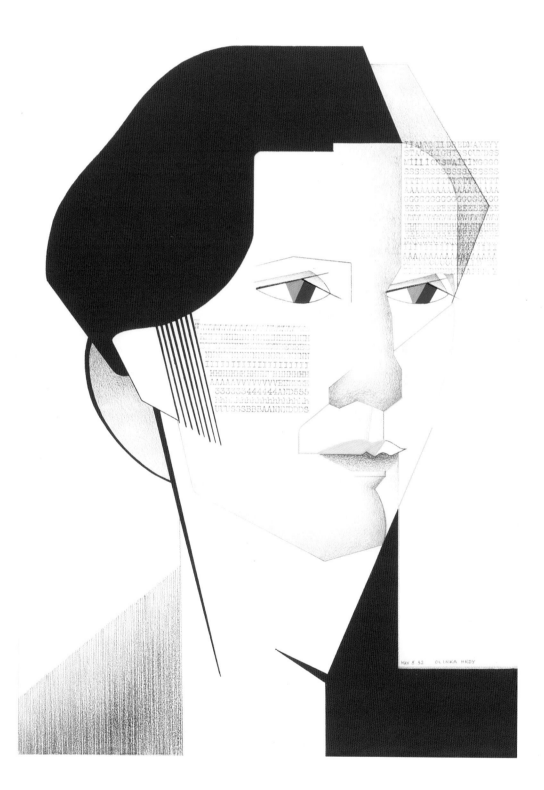

Fig. 52
Mildred Maxey, 1932
Tempera, colored pencil, and typing ink on paper, 14 ½ x 10"

Fig. 53
Phil McMann, early 1930s
Tempera and colored pencil on paper, 13 x 12″

its enigmatic inscription: "Mildred, as Freshman president, started this class out on the right track. She has what few people possess: natural dramatic ability. Who can forget her as Lady Macbeth or her dramatic appeal for the T-Club Hot Dog? There is no give-up in Mildred's nature … *Bitter Truth*: She is a wicked, wicked vamp – on the stage."[60] Clearly, the writer of Maxey's high school profile found her theatrical talents and seductive persona as humorous and noteworthy as Hrdy, at the same time offering some context for Hrdy's more cryptic text.

The combination of text and image in *Mildred Maxey* suggests Hrdy's familiarity with modernist portraiture such as Charles Demuth's poster portraits or El Lissitsky's *Self-Portrait: The Constructor*, 1924. *Mildred Maxey* is far less conceptual than either Demuth or El Lissitsky, but the image provides further proof of the Oklahoman's knowledge of modernist developments. Hrdy considered *Mildred Maxey* and her other portraits the culmination of her studies in Dynamic Symmetry, and she debuted them in an exhibition at the Master Institute in April 1933. This exhibition also seems to have concluded Hrdy's study at the Institute, and her wanderlust would soon prompt her to depart New York City.

While studying at the Master Institute, Hrdy also held a job with Swiss-born silk designer Hans Schweizer. Little information on Schweizer or his company, H. Schweizer, Inc., exists, but he had some education in modern art in France and Germany before arriving in New York around 1923 at the age of twenty. H. Schweizer, Inc. seemingly had a profound influence on silk scarf design in the U.S., originating a style that a *New York Evening Post* reporter described as "flat, stylized flowers, bold, bright blobs of color on the then unheard-of black background."[61] Hrdy's scarf designs for Schweizer exist only in verbal recollections, and her experience with modern design in Oklahoma and the Master Institute seems to have influenced her scarves. She described one as undulating waves of gray dots on a contrasting gray background, which may or may not have pleased Schweizer, considering he claimed in 1932 that plaids were the most fashionable scarf design for the coming season.[62] According to Hrdy, though, she became Schweizer's chief designer shortly after arriving in New York City; however, the job was short-lived and Hrdy found herself unemployed in early 1933 at the conclusion of the silk season and several months before Schweizer's untimely death in an automobile accident that November.

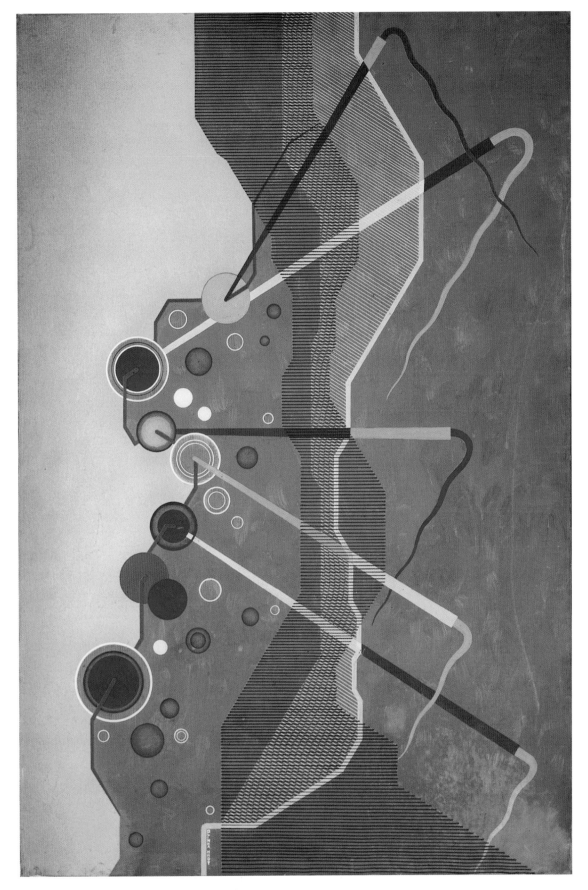

Fig. 54
Lake Shore, c. 1933
Oil on canvas, 24 x 36"

Chicago and Taliesin (1933)

With her employment at Schweizer's concluded and her studies at the
Master Institute drawing to a close in the spring of 1933, Hrdy sought further
opportunity outside of New York City, and she approached Frank Lloyd Wright
with the hope of teaching creative design at his new school, Taliesin, in Spring
Green, Wisconsin. The two had met in Tulsa in 1929 through Goff, following a
lecture by Wright. Hrdy requested no pay but asked for room and board and
some instruction in architecture. Karl Jensen, Wright's assistant at the time,
responded by sending the hopeful artist materials on Taliesin and arranging
for an interview on 8 March 1933. A lack of funds may have prevented Hrdy
from keeping the interview, and she spent most of the spring at Iannelli's
studio in Park Ridge, Illinois. Iannelli was involved in various aspects of the
Century of Progress Exposition during this time, and Hrdy later noted that she
assisted him in the design of posters, trophies, and awards.[63] While Iannelli's
involvement with notable fair attractions such as Enchanted Island, the
Havoline Thermometer Tower, and the Radio Entrance to the Hall of Social
Sciences is well documented, his role, or that of Hrdy's, in both the honors and
ephemera of the exposition is unclear. Her contribution could not have been
great since she was called to Cawker City, Kansas, in July to attend to her ailing
brother. However, Hrdy did produce a painting based on her experience with the
exposition, *Lake Shore (Oil No. 2)* (fig. 54; p. 47), and she described the painting
as an aerial view of the exposition along Lake Shore Drive inspired by both
personal experience and photographs:

> No. 2 is my first impression of the world's fair in Chicago –
> the green water lake line, the circles representing the bright-
> colored buildings with large flags flying in the wind. The
> delicate lines overlapping in pattern suggest the movement
> of cars going up and down the wide boulevard. (From
> photographic impressions I've seen taken of cars passing
> each other at night). This abstraction is the result of the
> feeling I remember definitely of having after seeing the
> fair in the afternoon, and that same night riding up and
> down the boulevard past the fairgrounds and linking that
> together with photographs I'd seen some years before.[64]

As such, *Lake Shore*'s geometric simplicity represents a synthesis of direct
stimuli and mechanical reproduction. Hrdy also must have relied on aerial maps
of the exposition, but her simplified waving flags are difficult to associate with
actual buildings at the exposition. Using photography as a means towards

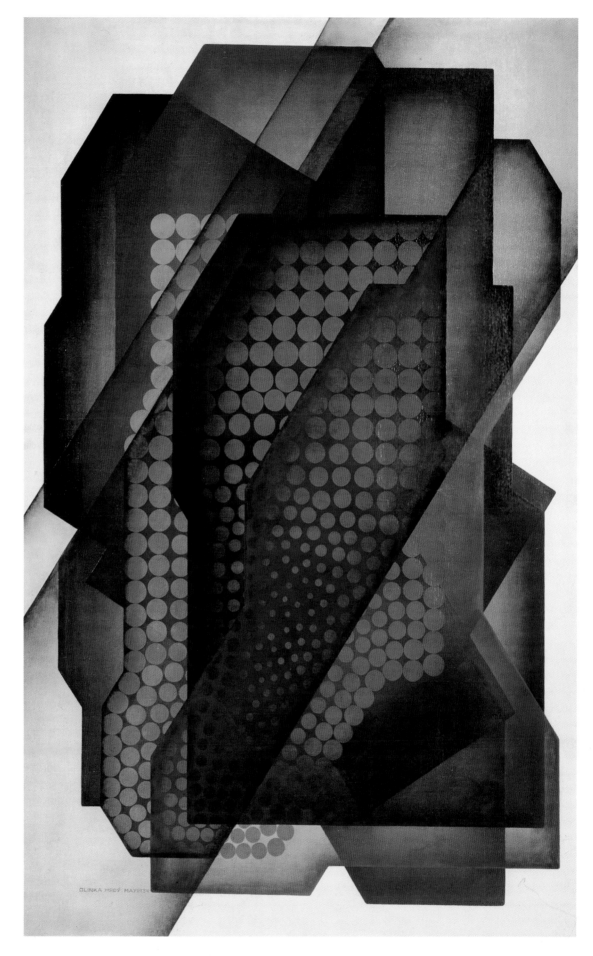

Fig. 55
Design (Exposition Park), 1934
Oil on canvas, 96½ x 60½"
Los Angeles County Museum of Art

abstraction, Hrdy embarked on an aesthetic direction similar to that of Georgia O'Keeffe, who frequently used the camera as an intermediary between herself and her subject.[65]

During her stay in Kansas, Hrdy mailed her portfolio to Wright for constructive criticism and with continued hope of obtaining a position at Taliesin. Wright responded favorably at the end of July and offered a few promising words, referring to the Turner Falls drawings as "true poems" and finding "something good" in the Riverside Studio murals, although he felt that the portraits were less successful.[66] Wright's receptive letter was unable to speed Hrdy along, and she did not depart for Wisconsin until the end of August. Her time there was brief, unfortunately, and by the end of September she had left Taliesin under mysterious circumstances. A letter dated 12 September from student Bob Mosher laments Hrdy's departure "especially because the causes were so unnatural and petty on the part of others."[67] No reason has yet been uncovered and the "others" of which Mosher speaks are unknown.

Notwithstanding, Hrdy did maintain good relations with Wright after leaving Taliesin as is indicated by her letter announcing a recent move to Hollywood in early 1934. She seemed to hold no ill will, admitting to Wright that "Very often I think of Taliesin and Hillside and wonder how things are progressing there."[68]

Hrdy in California (1933-1965)

With the brief experience at Taliesin behind her, Hrdy attempted to find employment in Depression-era California. Her financial situation qualified her for federal relief through the Public Works of Art Project, and she participated in the PWAP exhibition at Los Angeles County Museum of Art in May 1934 with a new mural, *Design (Expostion Park)* (fig. 55; p. 49). The mural was never installed as intended but became part of LACMA's permanent collection.[69]

Design (Expostion Park) demonstrates that Art Deco continued to influence Hrdy while in California, but it also reveals her growing knowledge of Bauhaus aesthetics. The circular geometry and liberal use of gold recall her work for the Tulsa Convention Hall, but the investigation of light, shadow, and transparency through a geometric framework also suggests some familiarity with the constructions of Moholy-Nagy, such as his *Composition Z VIII*, 1924 (fig. 56). Moholy-Nagy considered light, shadow, and transparency to be aesthetic elements worthy of modernist investigation, and he first explored these elements in paint in 1921 before turning to photography and film as a more "technologically sophisticated" medium. For Moholy-Nagy, the projection

Fig. 56
László Moholy-Nagy (Hungary 1895-1946)
Composition Z VIII, 1924
Glue print on canvas, 45 x 52"

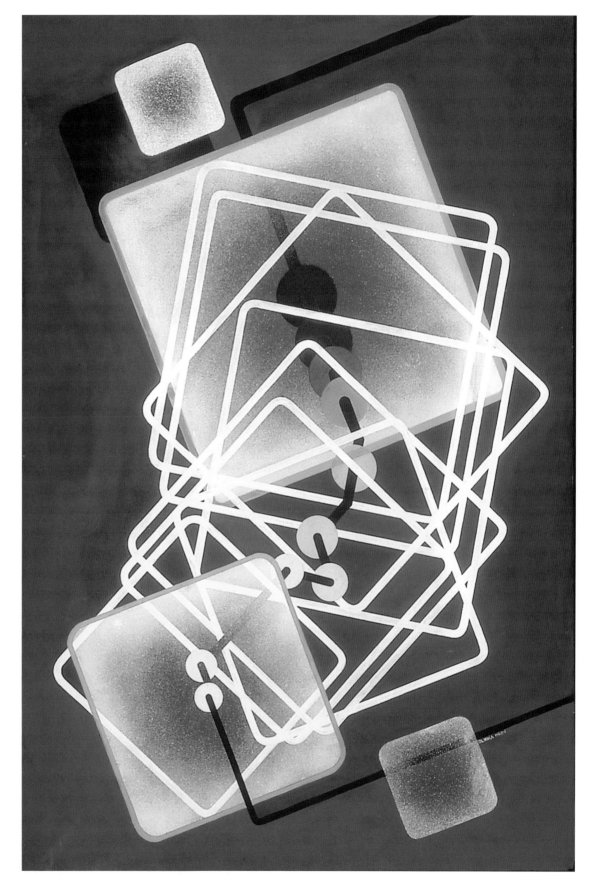

Fig. 57
Games, 1936
Oil on canvas, 36 x 24″

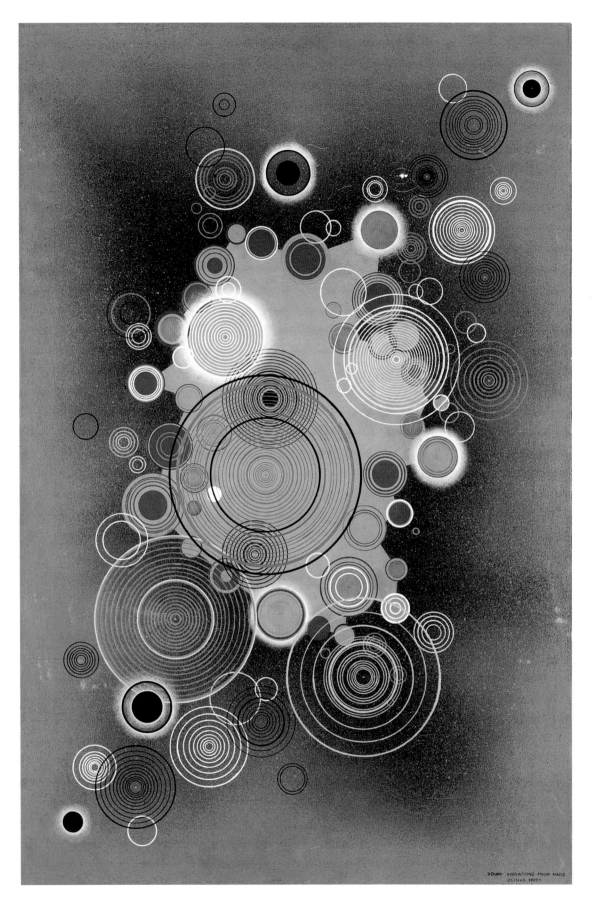

Fig. 58
Sound Vibrations from Mars (Cosmic Movement), 1934-53
Oil on canvas, 36 x 24"

of light on transparent forms represented the next stage in the investigation of space. As he claimed in his 1928 treatise, *The New Vision*, manipulation of light could "continuously change the composition," resulting in a work that was both spatially and temporally engaging. Transparent materials furthered this aim: "The use of transparencies, the ability of colors to change with subtlest differentiation through a nearby color, etc., enriches considerably the scope of new space relationships."[70] Hrdy may not have followed Moholy-Nagy in exploring the actual properties of light and transparency but she seems to have adopted his early investigations in paint as her model.

These aesthetic elements also informed Hrdy's *Games*, 1936, (fig. 57; p. 51) which appears to depict some sort of puzzle with beads strung along a wire. The transparent planes superimposed over the puzzle also create a game of visual trickery in that Hrdy's opaque medium simulates a clear material. In this regard, Hrdy suggests that artistic representation is a game played between artist and viewer in which the former attempts to fool or trick the latter into believing that the image is more than just an arrangement of pigment.

While the influence of Moholy-Nagy is present in both *Games* and *A Mysterious Shadow on Five Forms*, Hrdy also seems to have found inspiration from another Bauhaus painter, Wassily Kandinsky, in her contemporary work, *Sound Vibrations from Mars*, 1934-53 (fig. 58).[71] Kandinsky's Bauhaus works would have been far more readily available than those of Moholy-Nagy, and she might have attended Kandinsky's 1932 solo exhibition at Valentine Galleries in New York City or possibly even an exhibition of the Blue Four (Kandinsky, Paul Klee, Lyonel Feininger, and Alexey Jawlensky) at the Arts Club of Chicago that same year. *Sound Vibrations* compares closely to Kandinsky's *Circles in a Circle*, 1923 (fig. 59), which was included in the Chicago exhibition. As discussed previously, Hrdy was sympathetic to Kandinsky's ideas, and the work's use of concentric circles to suggest cosmic vibrations would have been consistent with Kandinsky's thought.[72]

Hrdy's experimentation with Bauhaus aesthetics in these 1930s works is surprising considering she had not visited Europe. The American organizations interested in Bauhaus aesthetics, namely the American Abstract Artists, the Chicago Bauhaus, and the Museum of Non-Objective Painting, had not yet formed.[73] Save for Dreier's Société Anonyme, there were few mentions of the Bauhaus in American periodicals before this time, and Hrdy's interest must be credited to her desire to study in Germany, a hope that was unrealized perhaps by diminishing funds or the rise of the Fascism.[74]

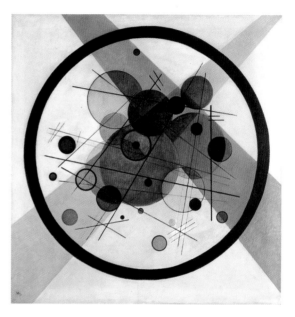

Fig. 59
Wassily Kandinsky (Russia 1866-1944)
Circles in a Circle, 1923
Oil on canvas, 38 7/8 x 37 5/8"
Philadelphia Museum of Art

Flower drawing – A. Lily

OLINKA HRDY.

Fig. 60
Flower Drawing – A. Lily, c. 1936
Graphite on paper, 13 x 16¼"

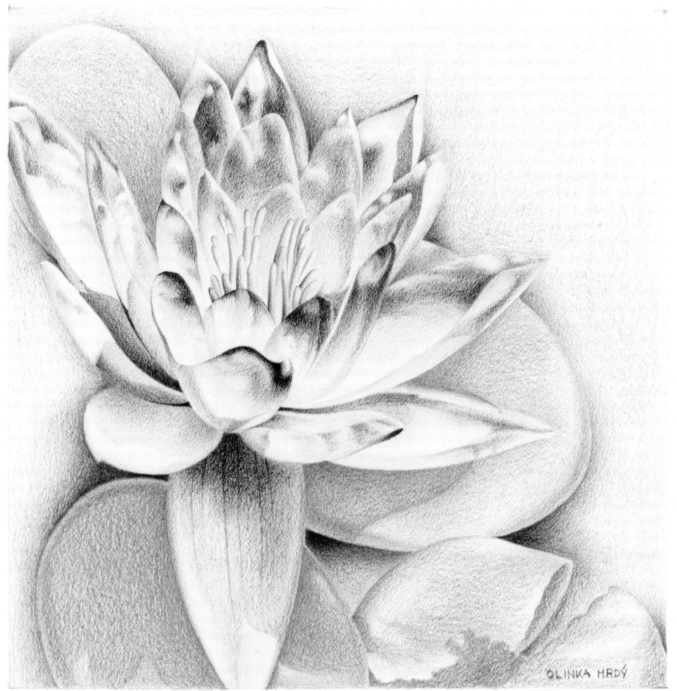

Fig. 61
Lotus, c. 1937
Colored pencil on paper, 11½ x 9½"

While Hrdy's easel painting generally embraced non-objectivity, much of her work for government agencies such as the PWAP and the subsequent Federal Art Project was representational. She produced numerous prints based on her Turner Falls drawings and on a new series of floral compositions she began in 1937. Her initial inspiration was likely an illustration commission she received for Margaret Preininger's 1936 book *Japanese Flower Arrangement for Modern Homes*. The commission required numerous technical diagrams of individual flowers, in addition to more complicated arrangements, and Hrdy seems to have utilized her knowledge of Dynamic Symmetry to illustrate the benefits of geometric design in a visual pleasing layout.

Hrdy's floral drawings from the following year favor close studies of a single bloom as were fashionable among modernists such as Georgia O'Keeffe, Imogen Cunningham, and fellow Californian Agnes Pelton, but Hrdy employed different levels of abstraction, preventing close comparison to any of the latter. In her *Flower Drawing – A.Lily* (fig. 60; p. 54), Hrdy suppressed the rounded forms of the flower in favor of angular leaves and petals informed by Dynamic Symmetry.[75] *Lotus* (fig. 61; p. 55), in contrast, relies far less on geometry but uses a firm line and a careful gradation of color to construct a naturalistic, yet overly precise, image of the blossom, comparable to Hrdy's non-objective paintings of the period. Given Hrdy's stylistic experimentation, she seems to have selected the flowers primarily for their formal potential or perhaps for the symbolism of the blossom. The lotus, for instance, is significant for Buddhists as a symbol of purity as well as being emblematic of the source of all creation, and Hrdy's growing awareness of Eastern religions may have enlightened her selection.

Floral compositions constituted the bulk of Hrdy's FAP print work, but she also completed at least one landscape, *Chalk Hill – California*, 1937 (fig. 62). Located in Sonoma County, Chalk Hill has long been devoted to agriculture and is now dominated by viticulture. *Chalk Hill* depicts a fecund earth whose swelling mounds have been plowed with neat furrows to produce an abundant crop, resulting in a striking similarity to the contemporary landscapes of Grant Wood.

Hrdy also produced two murals for the FAP during this time but only one, *Deep Sea Magic*, 1939, for Will Rogers Middle School in Long Beach survives. Painted on two 6 x 19' panels, *Deep Sea Magic* is a colorful study of undersea life teeming with a diversity of fish (figs. 63-65; p. 58). Her choice of subject matter was most likely determined by Long Beach's coastal location, and FAP mural supervisor Lorser Feitelson praised the "ingenuity and fine taste displayed in your design, and the delicacy and interest embodied in its content."[76]

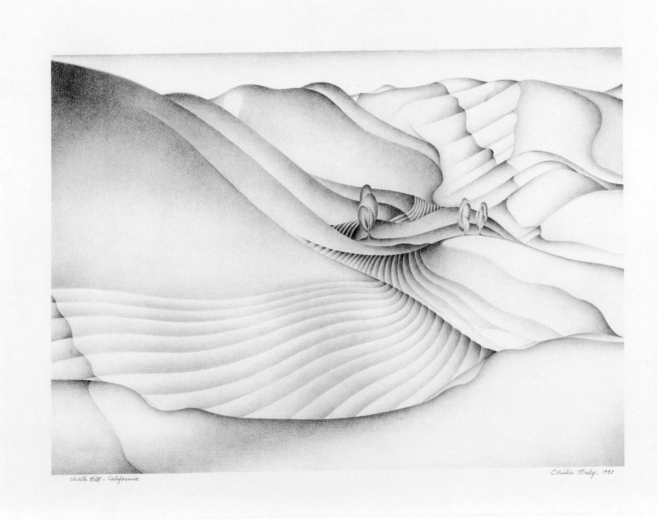

Fig. 62
Chalk Hill – California, 1937
Lithograph on paper, 14¾ x 20¼"

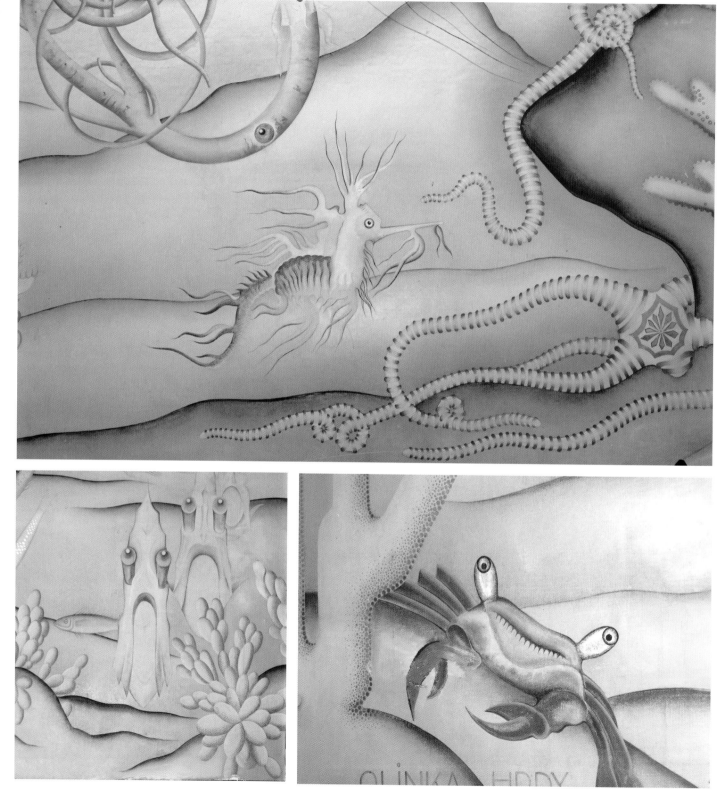

Figs. 63, 64, 65
Deep Sea Magic Mural, 1939 (details)
Tempera on plaster, 5' 11" x 19'
Will Rogers Middle School, Long Beach, CA

The technique Feitelson found so appealing is derived directly from Hrdy's murals for OU, particularly *The Pageant of Foods*, and her frontal views of fish draw on one particular panel, *Fish* (fig. 22; p. 23). Hrdy's second California mural, *Festival of Foods*, 1940, (destroyed) was designed for the cafeteria walls of Central Junior High School in Los Angeles (now the Board of Education) and was painted directly on acoustical plaster. Like *Deep Sea Magic*, it depended on *The Pageant of Foods* for its subject matter, which was an international survey of food.[77]

Apart from her affiliation with the WPA, Hrdy sought other venues for her growing body of work, and she exhibited her portraits and landscapes at Gustave Gilbert's art materials store in August 1934, Bullock's Wilshire Department Store in Los Angeles, and the Downtown Gallery in Tulsa in 1935. The year 1936 proved more eventful with two exhibitions at Stendahl Galleries in Los Angeles in September and November and an exhibition at Auriel Bessemer's Gallery of Modern Masters in Washington D. C. in December, which included many of the objects from the Downtown Gallery exhibition.[78] More importantly, Hrdy produced a mural based on her waterfall designs for the Twentieth Century House designed by Hugh R. Davis in Bixby Knolls, California in 1937.[79]

Hrdy's active exhibition schedule and her employment through the FAP in the 1930s represented a peak in her artistic activities, and the decline of the FAP in the early 1940s prompted Hrdy to accept a job as Chief Designer for the State of California at Exposition Park. According to the artist, she helped to design agricultural and ranching exhibitions for the Building of Science and Industry.[80] Her new position seems to have demanded much of her time and energy, and as a result she pursued her art career with less enthusiasm than previous decades. Oddly, Hrdy also seems to have been less interested in documenting her new career in industrial design, with little in the way of documentation following the 1930s.

The War Years

Hrdy's position at Exposition Park ended around 1942 with American entry into World War II, and she took a new position in the Electrical Department at Douglas Aircraft in Santa Monica. Hrdy's background included no training in electronics, but she, like many women during the war, learned new technical skills as a means of contributing to the war effort. Since most of Douglas's records from this period have been lost or destroyed, it is difficult to ascertain the duration of Hrdy's employment or her precise contribution to the war effort, though it is known that she received a commendation in 1944 for her development of a jig board with a sliding comb to help maintain parallel wiring.[81] Much of her work seems to have been for offensive weaponry, and at the

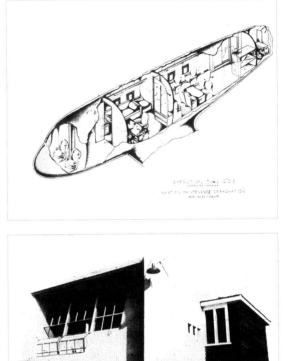

Fig. 66
Olinka Hrdy's Scrapbook
Photo of the interior design for a Douglas DC3, 1947

Fig. 67
Olinka Hrdy's Scrapbook
Photo of Solar Hill, Woodland Hills, California, 1950

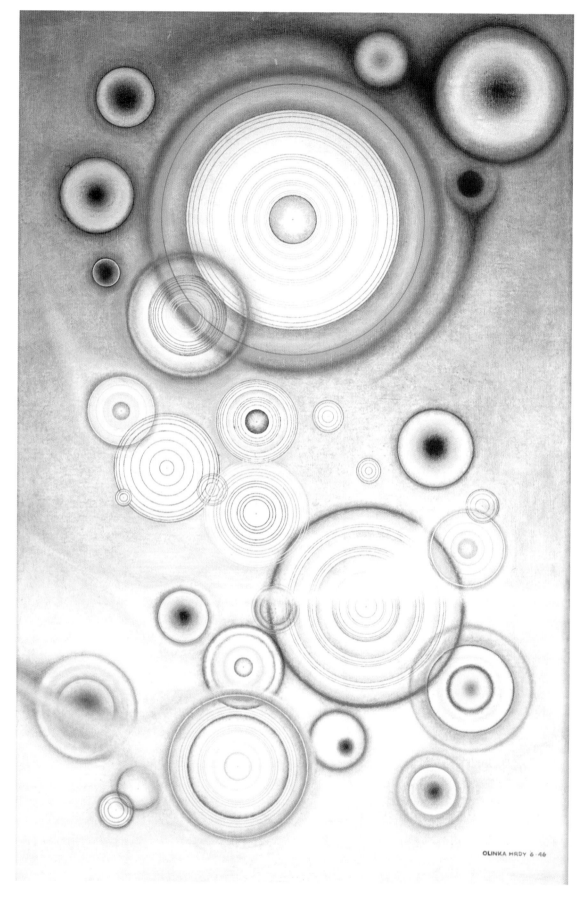

Fig. 68
Moving Sound, 1946
Oil and colored pencil on canvas, 36 x 24"

conclusion of WWII she began to question the ethics of her job: "one day I realized that my gun and bomb switches were … killing … out there men who were human beings with families somewhere."[82] Hrdy then left Douglas around 1945, but her affiliation probably earned her another commission in 1947 for the interior of a Douglas DC3 for an unnamed Maharajah of India that was outfitted with tan suede upholstery, a chocolate-colored davenport and bed, a cherry red rug, and gold-plated metal fixtures.[83] The results must have been visually striking, although only a black and white photograph remains (fig. 66; p. 59).

Hrdy's departure from Douglas coincided with her marriage to Ray Claire Tracy in 1945. Her papers contain no biographical information on her husband, and the marriage ended in divorce in December 1950. This may have led Hrdy to build a private studio outside her home, and in 1950, she completed construction on the building she called "Solar Hill" at 62 Blackbird Way near Woodland Hills (fig. 67; p. 59). She claimed that the building had been constructed from the remains of a drafting room once used by architect John Lautner, although no evidence exists of Lautner's involvement or Hrdy's relationship with him.[84]

The Late Paintings

Despite the building of Solar Hill, her artistic output was intermittent, as evinced by the extant works from this period. The art work she did produce in the postwar period tended towards archetypes as illustrated by two paintings from 1946, *Moving Sound* (fig. 68) and *Light* (fig. 72; p. 64). *Moving Sound* relies upon earlier works such as *Sound Vibrations from Mars*, with its concentric circles radiating outward like sound waves. Just as *Moving Sound* attempts to reduce phenomena to basic geometric forms, *Light* uses rectangular bands of color to suggest a refraction of light into its component parts, reflecting Hrdy's interest in crystalline structures as seen previously in works such as *Phil McMann*.

Both *Light* and *Moving Sound* may appear as artful investigations of physical phenomena, but it is likely that Hrdy found cosmic significance in her subjects, as she had in *Sound Vibrations from Mars*. Her comments about her work from the period suggest that she believed in an animistic nature and in the existence of the "oversoul," a transcendent spiritual essence composed of all souls. In the postwar years, she began a series of paintings known as Spiritual Experiments in which she sought some connection with the creative forces of the universe through artistic improvisation. As she explained to interviewer Betty Hoag in 1965:

Fig. 69
Olinka Hrdy's Scrapbook
Spiritual Experiments, not dated (dimensions and locations unknown)

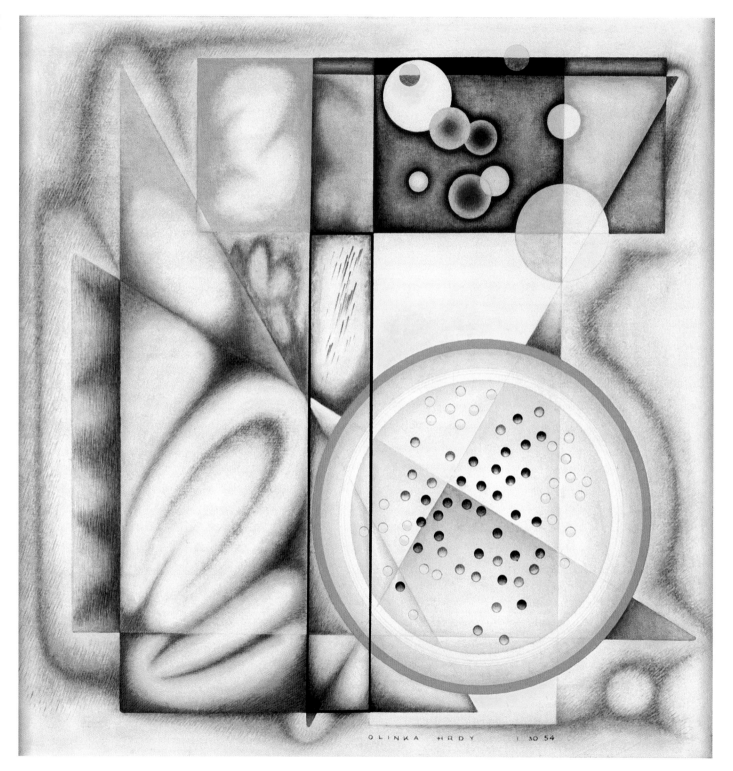

Fig. 70
Conception, 1954
Oil on canvas, 24 x 24″

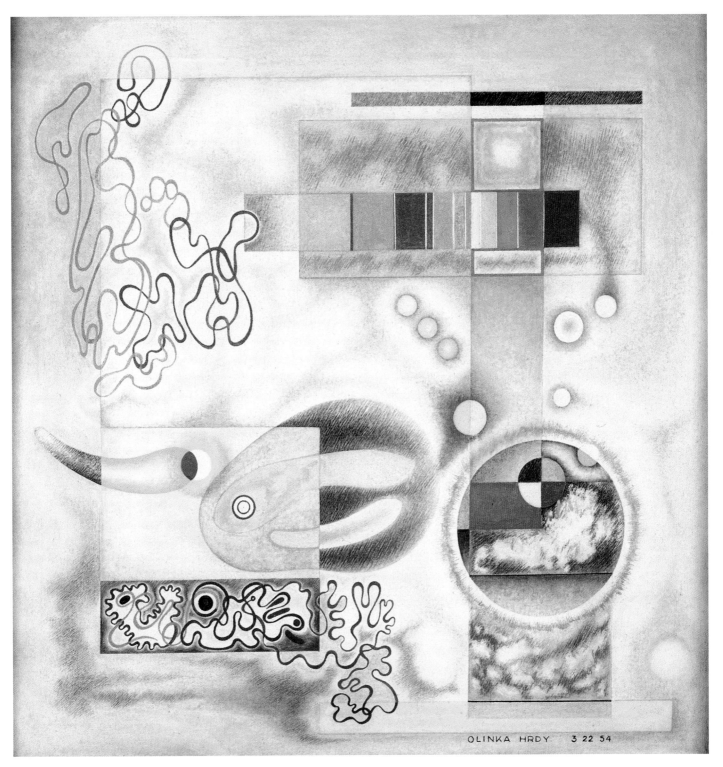

Fig. 71
Sex, 1954
Oil on canvas, 24 x 24"

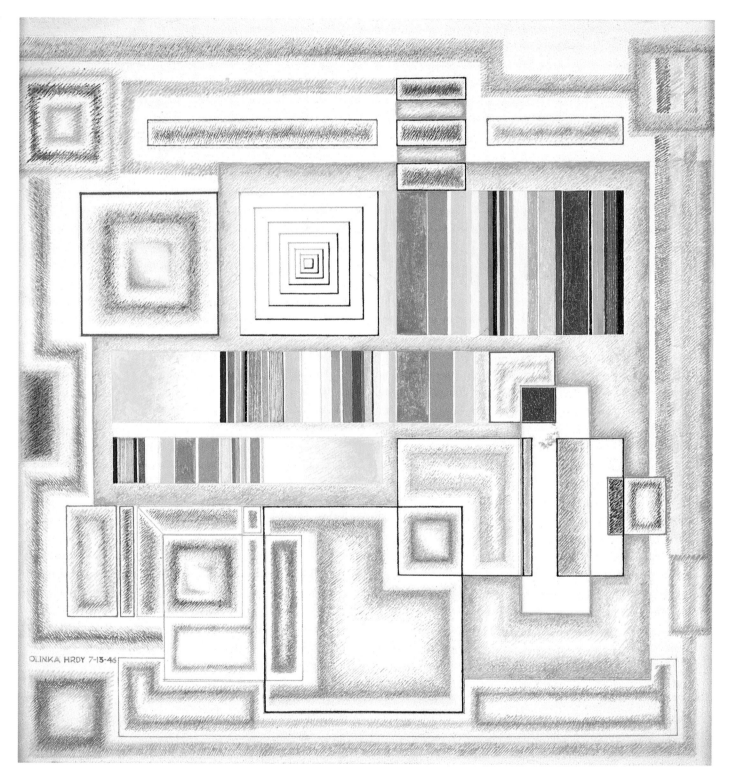

Fig. 72
Light, 1946
Oil on canvas, 24 x 24"

I began doing these things I call "Spiritual Experiments," watercolors, and always on my birthday, or on Christmas morning … early in the morning I get out here in my studio and I do these watercolors which are free flowing and actually I don't know what's going to happen. I have the least to do with it, and I claim the creative force flows through everybody, you and anybody walking down this street. They all have it but they don't know how to tap it. But once they learn how to tap it, it's amazing what you can do with that force.[85]

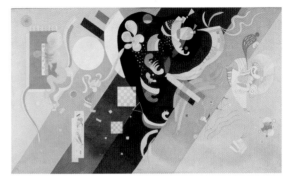

Although the majority of these Spiritual Experiments have been lost, reproductions (fig. 69; p. 61) indicate a decidedly non-representational approach, and Hrdy saw non-objectivity as the best means of exploring the impalpable energies of the cosmos. The paintings of her later career were not only non-objective but built upon her investigation of archetypal themes. Creative, generative forces inspired her ongoing Spiritual Experiments and likely formed the impetus behind two paintings from 1954: *Conception* (fig. 70; p. 62) and *Sex* (fig. 71; p. 63). *Conception* relies on a geometric composition similar to that of *Light* to depict the fertilization of an egg cell and its subsequent division in the womb to produce an embryo. Soft edges define the reproductive organs while a taut contour describes the egg cells, suggesting an inference to the circular forms and cosmic significance found in *Moving Sound* and *Sound Vibrations from Mars*.

As such, *Conception* was likely intended as an analogy between the microcosmic, procreative energies of biological life and the macrocosmic energies of the universe. Similarly, the motivation behind *Sex*, a distinctly different painting from *Conception,* yet sharing a thematic correlation, incorporates many of the compositional devices found in earlier paintings such as *Moving Sound* and *Conception,* and in the prismatic registers from *Light*. Hrdy downplayed the geometric framework that seemed to dominate her previous paintings, and the gestural passages imitating spermatozoa, Golgi, mitochondria, and endoplasmic reticulum convey a spontaneity absent in her previous works. When paired with the more rigid geometric elements, the result is not unlike Kandinsky's late paintings with their combinations of biomorphic and geometric elements arranged in registers, as in his *Composition IX*, 1936 (fig. 73).

Fig. 73
Wassily Kandinsky (Russia 1866-1944)
Composition IX, 1936
Oil on canvas; 44⅝ x 76¾"
Musee National d'Art Moderne, Centre Georges Pompidou, Paris

Fig. 74
Untitled, n.d.
Oil on paper 8 x 26½"

Fig. 75
Sam Francis (U.S. 1923-1994)
Untitled, 1983
Acrylic on rice paper, 72 x 37¼"

The improvisation implied by the tangled lines may also reference Hrdy's awareness of Abstract Expressionism, and she produced at least one painting (fig. 74; pp. 66-67) in her later career that imitates the gestural dripping of Jackson Pollock and Sam Francis (fig. 75; p. 67). However, Hrdy's enthusiasm for easel painting seems to have waned by the mid-1950s, and she produced little thereafter.

Hrdy and Industrial Design in the Postwar Years

Following World War II, Hrdy devoted more time to design than painting, even though she lacked formal training.[86] She had flirted with flatware design briefly in 1929 when she entered a competition sponsored by flatware manufacturers Holmes and Edwards, and limited experience may have come from Iannelli, with whom she worked intermittently between 1929-33. Her subsequent employment at Exposition Park and especially Douglas Aircraft provided her with more practical experience, but her transition into the industrial design field after World War II was atypical for many women. Whereas many women received training in drafting, engineering, and mechanical design by wartime industry, the postwar period saw the reassertion of traditional labor roles, and many women returned to design fields that were considered socially acceptable for women such as textiles, jewelry, metalwork, and interior design.[87]

Hrdy may have been one of the few women to enter the field of industrial design, yet her contributions have never received historical recognition. As Ella Howard and Eric Setliff have demonstrated, women are rarely mentioned in the history of industrial design, and while it is possible that Hrdy's omission may be the result of gender bias, it must be noted that the majority of her designs exist only in draft and finished products; evidentiary photographs and patents have not come to light.[88] While this suggests that her influence as a designer was limited, her designs do provide insights into the development of Hrdy's career and occasionally reveal novel and innovative ideas.

Hrdy's designs compare closely to those of prominent 1930s designers in the U.S., such as Norman Bel Geddes, Henry Dreyfuss, Raymond Loewy, and Russel Wright, and to those of the Bauhaus. Much of her work in the 1940s and '50s clearly favored both the streamlining and horizontality of 1930s American industrial design and the geometric aesthetic of the Bauhaus, as opposed to the organic and biomorphic forms that became increasingly prevalent during the Atomic Age.[89] The geometric abstraction that dominated Hrdy's paintings from this period often functioned as research for product design. This tendency suggests further identification with Moholy-Nagy, who frequently advocated modernism as a laboratory for advancements in design, and with mid-century designers such as Russel Wright, who once claimed:

Fig. 76
Olinka Hrdy's Scrapbook
Ebony Radio Cabinet for Hanson Music Company, 1945

Fig. 77
Magazine Rack, 1945
Graphite and colored pencil on paper, 14 x 17"

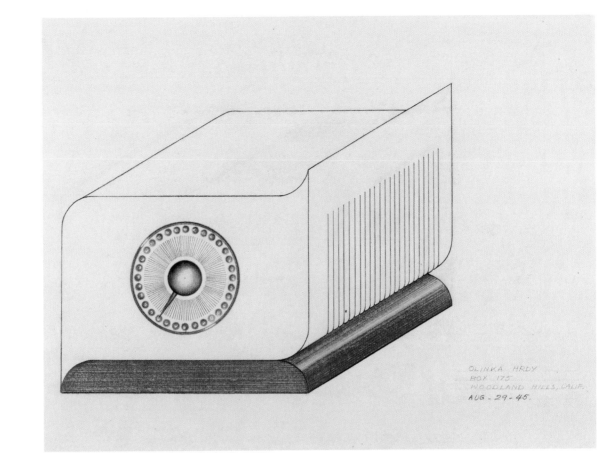

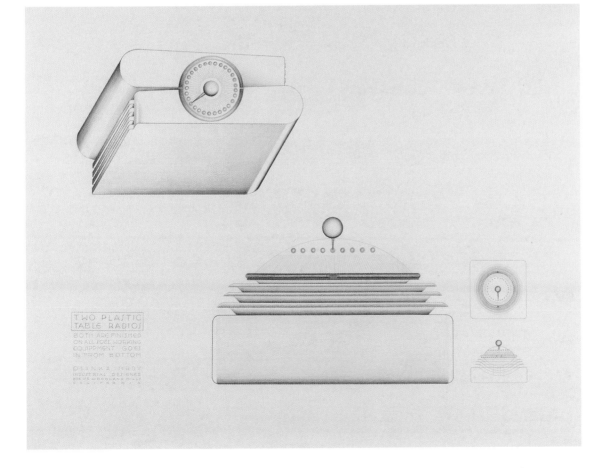

Fig. 78
Radio Design, 1945
Graphite and colored pencil on paper, 14 x 17"

Fig. 79
Radio Design, c. 1945
Graphite and colored pencil on paper, 23 x 29"

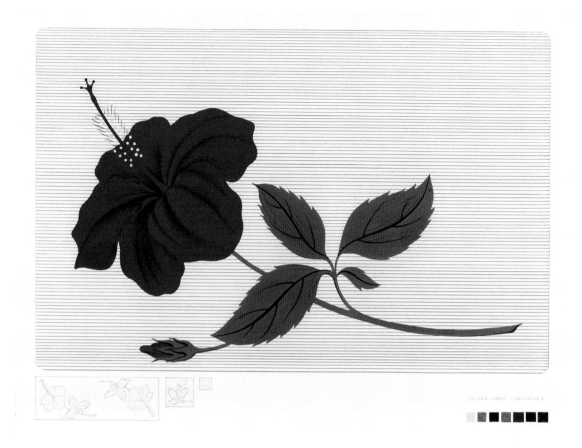

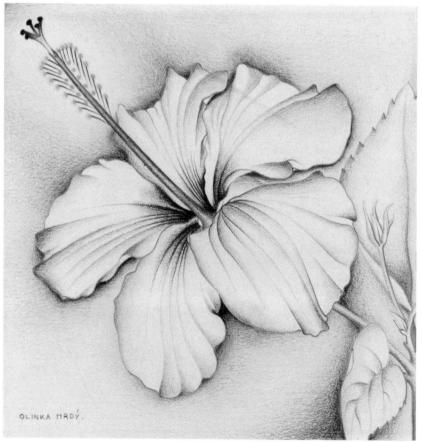

Fig. 80

Hybiscus (Table Mat Design), n.d.

Tempera and graphite on paper, 15 x 20″

Gift of the artist, 1966

Fig. 81

Untitled, 1937

Colored pencil on paper, 11½ x 10″

Gift of the artist, 1966

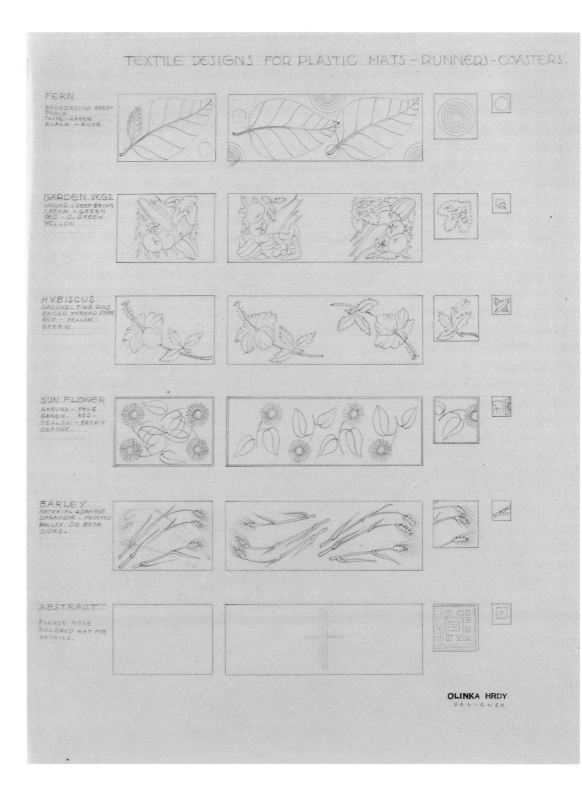

Fig. 82
Textile Designs for Plastic Mats–Runners–Coasters, n.d.
Graphite on paper, 17 x 14"

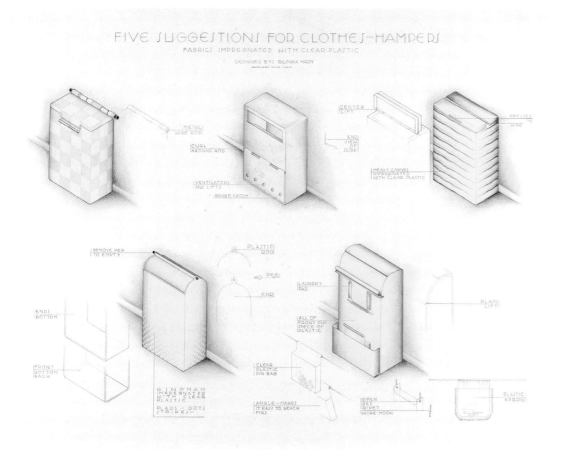

FIVE SUGGESTIONS FOR CLOTHES–HAMPERS

FABRICS IMPREGNATED WITH CLEAR PLASTIC

DESIGNED BY: OLINKA HRDY

Fig. 83

Five Suggestions for Clothes–Hampers, n.d.

Tempera and graphite on paper, 15 x 20"

Fig. 84

Office–Wastebasket, n.d.

Graphite and colored pencil on paper, 36 x 24"

I know that when I see the work of one of our better painters, particularly the abstractionists, I am greatly stimulated. Why? Because these men, too, are working with abstract form, line and color – my own daily diet. Because I find them working in the same direction that I try to push my own work … these men are performing the experiments I should like to have had time for.[90]

The forms and lines of paintings such as *Conception* and *Light* heavily influenced Hrdy's designs for commercial and industrial products. She focused on radio design throughout the 1940s and '50s, which is unsurprising given her interest in sound and her experiences in electronics at Douglas, and she relied upon a design aesthetic drawn from geometric abstraction. Hrdy began working for Hanson Music Company in Beverly Hills at an unknown date following her departure from Douglas. As one of her first projects, she designed an ebony radio cabinet (fig. 76; p. 68) with "a magnetic catch" that when pressed opened the doors and activated the interior illumination, innovations that are now common in cabinet design.[91] The cabinet lacked any exterior ornament, emphasizing the straight lines and rectangular forms of the construction, and Hrdy designed the structure aesthetically from all sides to avoid the visual interruption of a false back. As such, it could be placed anywhere in a room and was large enough to contain a radio, record player, tape recorder and speakers, thereby reducing the clutter of individual units.

She also proposed the cabinet for a radio and recorder with an accompanying magazine rack (fig. 77; p. 68). All the designs are dominated by straight lines and sharp corners, particularly the magazine rack and its angular spiral, which compares closely to the rectangular structures of *Light*.

In addition to her work for Hanson, Hrdy designed a trio of radios for an unnamed plastics firm in the 1940s (figs. 78-79; p. 69). Similarities in the dial configuration suggest that all the designs may date to 1945.[92] Hrdy's designs for the radios casings display the sleek streamlining, rounded corners, and horizontality that were characteristic of 1930s product design and made possible through the malleability of plastics.[93] Her most innovative design was composed of a plastic dome, which served as a nightlight, set atop what seems to be a grill, with speakers positioned near the base and hidden behind the molded boards.[94] Hrdy intended for the radio to sit atop a kitchen table, so she realized the design from all angles, similar to the Hanson ebony cabinet. As she explained, "most radios have a sham back and you have to set it against the wall so you don't see all the works in there, but this one as you see is complete all around and these two are handles, you just pick it up by these handles like you do a teapot or something."[95] Similar to a kitchen appliance, the radio was

Fig. 85
Radio Cabinet, c. 1950
Gelatin silver print, 7⅛ x 8⅝"

Fig. 86
Olinka Hrdy's Scrapbook
Exhibit for the Los Angeles Bee Keeper's Association, 1952

easily portable, but equally important, her combination of radio and nightlight was innovative and predates much of the bundling of technology that occurred in the 1960s and '70s.

The unnamed plastics firm must have valued Hrdy's radio designs, and she produced tablemats (fig. 82; p. 71), wastebaskets (fig. 84; p. 72), clothes hampers (fig. 83; p. 72), and possibly even wallpaper for them.[96] Many of the designs relied in some way on Hrdy's earlier flower drawings and depict in detail blossoms, grains, or vegetables (figs. 80-81; p. 70). Some designs formed the basis for an entire set of dining accessories including tablemats, table runners, and coasters (fig. 82; p. 71) and would have been printed on organdy and laminated in plastic. Her design work was not limited to the "decorative," and she often attempted structural innovations in her proposals for wastebaskets and clothes hampers to increase efficiency or save space (figs. 83-84; p. 72).

In the 1950s, Hrdy also worked for Hycon Manufacturing Company, which was founded in 1948 in Pasadena and later purchased by McDonnell Douglas. Her previous radio designs and proposals for other electronics led her to more sophisticated radio cabinets for airplanes and sea vessels, and in 1952 she also received a favorable mention in Hycon's newsletter for a honey exhibit she had designed for the Los Angeles Bee Keeper's Association (fig. 86; p. 73). Complete with a magnified three-dimensional representation of a honey bee, the exhibit clearly drew upon her work at Exposition Park in the early 1940s.[97]

The length of Hrdy's employment with Hycon is unknown, but it is clear that her creative efforts, whether in design or the fine arts, waned considerably by the 1960s. When she engaged in aesthetic activities later in life, she devoted herself almost exclusively to book illustration. In 1961, she completed illustrations for June Johnson's *Outdoor-Indoor Fun Book*, a treasury of everyday games, family and group activities, party and holiday ideas for children from six to twelve (fig. 87). Her cover illustration recalls the costume designs for Oskar Schlemmer's *Triadic Ballet*, providing further evidence of Hrdy's sympathies with German design.

Hrdy's Return to Oklahoma (1965-1987)

In 1965, Hrdy began planning a return to her birthplace in Prague, Oklahoma, and the following year she gave most of her personal collection to the Museum of Art at the University of Oklahoma, now the Fred Jones Jr. Museum of Art. The museum honored the gift with a retrospective in 1966 upon Hrdy's official return to her native state. She spent her remaining years in Prague as a local celebrity but produced little art or design during this time. Her papers offer little information as to her activities in these years. In the mid-1970s, she worked intermittently at a commune in Summertown, Tennessee, with 800 agriculture

Fig. 87
June Johnson
Outdoor-Indoor Fun Book (New York: Gramercy, 1961)
Book, 8¼ x 5⅝ x 1"

students from the University of California, Berkeley. Although the commune is not named in her papers, it was likely The Farm, a 1,750-acre agricultural commune founded around 1970 by Stephen Gaskin, a former San Francisco State University professor. The commune valued vegetarianism, anti-materialism, and spiritual education in multiple religious traditions, all of which may have appealed to Hrdy. She reportedly illustrated a book for them entitled *How the World and We Began*, although no evidence of the book has been discovered.[98]

She also planned in 1977 to publish *By A Waterfall: The Day Dreams of Wekiwa – The Seminole Maiden*, an illustrated children's book, but the publication never came to fruition and only the cover illustration survives.[99] Hrdy seems to have spent much of her time in Prague on pursuits outside art and design. She died in 1987.

Hrdy's career may not have been incredibly prolific, but she produced some truly significant works that offer a new perspective on the growth of modernism in the United States. From Art Deco, Bauhaus aesthetics, and international Constructivism, she forged a style that compares closely to developments in European modernism. More importantly, her example demonstrates that the influence of modernism in the U.S. was more widespread than usually assumed. Her career also provides a significant link between modernist abstraction and industrial design and indicates that she translated the formal concerns of non-objectivity into design principles. In this regard, Olinka Hrdy played an important yet frequently unnoticed role in the development of modernist art and design in Oklahoma, New York, and California, and she deserves further examination for her valuable contribution.

Fig. 88
Unknown Artist
Olinka Hrdy, 1965
Gelatin silver print, 10 x 8"

Endnotes

[1] Basic research on Hrdy comes from Olinka Hrdy, interview with Betty Hoag, 13 March 1965, transcript, Smithsonian Archives of American Art (AAA), http://www.aaa.si.edu/oralhist/hrdy65.htm. However, much of the information Hrdy provided in the interview is subject to error and embellishment, so verification through secondary sources has been required. Hrdy's history is also complicated by confusion surrounding her name. Early in her academic career, she substituted "Olive" for "Olinka" possibly for ease in social situations. Her last name, Hrdy, has often been erroneously transcribed as "Hardy" or "Herdy."

Although Hrdy's birthplace of Prague shares the spelling of the Czech capitol, the pronunciation is (prāg) with a decidedly Oklahoman flavor.

[2] Certificate of Marriage, Joseph Hrdy to Emma Benesh, 30 December 1899, Lincoln County Court House, Chandler, Oklahoma.

[3] The cabin and homestead are recorded in Deed of Sale from Franc Mastina to Joseph Hrdy, August 1902, Lincoln County, Oklahoma, book 13, p. 102. Lincoln County Court House, Chandler, Oklahoma. His purchase of downtown lot 7, block 27 is recorded in Deed of Sale from E. L. and Olive J. Conklin to Joseph Hrdy, August 1902, Lincoln County, Oklahoma, book 13, p. 108. Lincoln County Court House, Chandler, Oklahoma.

[4] Hrdy, interview with Hoag, p. 1. No documentation of this divorce exists in the records of Lincoln County, suggesting that the couple either divorced in a neighboring county or the divorce was never legally recognized.

[5] Betty Kirk, "Girl Artist Paints Her Way Through Year In University," Olinka Hrdy curatorial files, Fred Jones Jr. Museum of Art, University of Oklahoma, Norman. The lease was probably from a Sac and Fox tribal owner, but records no longer exist on lease agreements on Sac and Fox land.

[6] Hrdy quoted in "Olinka Hrdy," Olinka Hrdy papers, Lincoln County Historical Society, Chandler, Oklahoma.

[7] It has often been supposed that Hrdy is of Native American ancestry; however, in an interview with art collector Arthur Silberman, she clarified that she had no Native American heritage. Olinka Hrdy, taped interview with Arthur Silberman, 1981, tape 96.017.1040.450, Arthur Silberman Papers, Donald C. and Elizabeth M. Dickinson Research Center, National Cowboy Museum and Western Heritage Center, Oklahoma City. Silberman interviewed Hrdy on multiple occasions between 1980-83 and all of the tapes have been deposited at the Dickinson Research Center.

[8] Hrdy, interview with Hoag, p. 4-5.

[9] It is likely that Hrdy knew the work of the Bauhaus, and a 1930 letter written in German requesting a catalogue on "Individual Light Regulators" in the possession of the Prague Historical Society indicates that she knew the language. Late in life, she reported to Arthur Silberman that she had hoped to study in Germany in the early 1930s. Hrdy, interview with Arthur Silberman, 1980s, tape 96.017.1040.512, Silberman Papers.

[10] Hrdy's transcript from Oklahoma A&M reveals little about her studies. A letter dated 9 September 1923 from L.W. Burton, Registrar of Oklahoma A&M, lists nothing more than the three courses in which she was enrolled: Textiles, Art, and Home Planning. It is likely that Textiles was a course on sewing, but no information on course content survives. The transcript was included in Hrdy's scrapbook, which has disappeared, but is preserved on microfilm at the Archives of American Art. Olinka Hrdy Papers, Archives of American Art, reel LA7, frame 1039.

[11] Mary Schoeser and Whitney Blausen, "'Wellpaying Self Support': Women Textile Designers in the USA," in Pat Kirkham, ed., *Women Designers in the USA*, *1900-2000: Diversity and Difference*, 2nd ed. (New Haven, Connecticut: Yale University Press, 2002), 147-48.

[12] Hrdy exhibited a woodcut entitled *Lady Luck*, a lacquer box, and the oil painting *Maiden Head Rock*, all of which are now lost. The works are recorded on Hrdy's resume in "Kiowa-Olinka Hrdy, 1932-1982," Silberman Papers, box 10, folder 1, Dickinson Research Center.

[13] Unidentified author, "Art Students Make Trip to Tishomingo," Olinka Hrdy Papers, reel LA7, frame 1013, Archives of American Art, Smithsonian Institution, Washington, D.C.

[14] Jeanne d'Ucel, "Olinka Hrdy: Her Genius Wins Applause in the Art World Through Modern Masterpieces," *The Sooner Magazine* 1, no. 10 (July 1929): 344.

[15] The history of the Wentz-Matzene gift is found in Eric McCauley Lee and Rima Canaan, *The Fred Jones Jr. Museum of Art at the University of Oklahoma: Selected Works* (Norman: University of Oklahoma Press, 2004), 11. The collection is dominated by Buddhist sculpture but does include other media, including Persian manuscripts. Interestingly, an unknown critic also suggested a Persian quality in the Turner Falls compositions. "Hrdy Exhibition Novel; First Guild Show Opens," *Tulsa Daily World*, 1 November 1936, sec. 4, p. 2.

[16] Hrdy's representation at the A&M exhibition is listed in her resume in "Kiowa-Olinka Hrdy, 1932-1982," Silberman Papers, box 10, folder 1, Dickinson Research Center.

[17] The only reference to the Key mural exists in "Accomplishments," Olinka Hrdy papers, Lincoln County Historical Society. The mural has vanished along with much of Hrdy's mural work from this period.

[18] Hrdy, interview with Arthur Silberman, 1 June 1980, tape 96.017.1040.028, Silberman Papers.

[19] Hrdy, interview with Hoag, p. 2. Her father refused to provide money for her education, reportedly arguing "that women should get married, scrub floors, and have kids." Hrdy, interview with Arthur Silberman, 1 June 1980, tape 96.017.1040.028, Silberman Papers.

[20] It is unknown how much compensation Hrdy received for *Maker of Dreams*. For further information on Mahier's mural classes see "Paintings and Murals by Oklahoma Girl Accorded Exceptional Praise," *The Daily Oklahoman*, 15 September 1929, p. C5; "Murals Selected For Business Structure," *The Oklahoma Daily*, 12 March 1936, p. 1; and "Murals by Student Artists To Adorn Hall and Office Of New Business Building," *The Oklahoma Daily*, 27 March 1936, p. 1, 3.

[21] Hrdy, interview with Silberman, 1 June 1980, tape 96.017.1040.028, Silberman Papers.

[22] She completed the first ten murals on 10 May 1927 and finished the remaining ten the following year on 15 May. The title, *The Pageant of Foods*, is derived from an illustration of part of the cycle in *Sooner Magazine* 1, no. 10 (July 1929): 344-45. Hrdy identifies the cycle in her résumé as *The Harvest of Foods* in "Kiowa-Olinka Hrdy, 1932-1982," Silberman Papers, box 10, folder 1, Dickinson Research Center. Her résumé lists the first ten murals as *Sea Foods, Rice, Pineapples, Bananas, King of the Fruits, Queen of the Flowers, Coconuts, Pumpkins, Watermelons*, and *Fish*. The following ten were titled *Corn, Wild Game, Oranges, Fowl, Dates, Water, Artichoke, Grapes, Meat*, and *Chili Peppers*. None of the decorations have survived. Hrdy claimed that the doors were given to a museum in Tulsa but no evidence of them exists. Hrdy, interview with Hoag, p. 4.

[23] Hrdy, interview with Hoag, p. 4.

[24] William C. Gallaspy, letter to the Prague Historical Society, 2 October 2004, Olinka Hrdy Papers, Prague Historical Society, Prague, Oklahoma, and d'Ucel, p. 345.

[25] "Medievalism Is Depicted In Finished Murals By Olinka Hrdy in 'Kettle,'" unknown paper, 17 May 1928, Hrdy Papers, AAA, LA7: 1027.

[26] Hrdy was married to Ray Claire Tracy between 1945-50, but little else is known about her personal relationships. She did admit to Joe Price, a petroleum pipeline manufacturer and former client of Goff's, that she had fallen in love with the latter's assistant John McCurry, during her stay in Tulsa between 1929-31. Hrdy quoted in *David De Long, Bruce Goff: Toward Absolute Architecture* (Cambridge, Massachusetts: MIT Press, 1988), 49.

[27] For further information on the New Woman, see Martha H. Patterson, *Beyond the Gibson Girl: Reimagining the American New Woman, 1895-1915* (University of Illinois Press: 2005).

[28] Barbara Haskell, *The American Century: Art and Culture, 1900-1950* (New York: Whitney Museum of American Art, 1999), 177. The date of the photographs is confirmed by a page from Hrdy's scrapbook that records 1 February 1931. Hrdy Papers, AAA, LA7: 1058.

[29] Unidentified author, "O.U. Athlete To Pose for Art Murals," unidentified newspaper, 11 October 1928, Hrdy Papers, AAA, LA7: 1029. She placed the final touches on the mural on 10 November, but decided not to sign the work. Later in 1981, the new owner of the building, Southwestern Bell Telephone, asked the elderly artist to return and sign her murals. Bob L. Blackburn, *One Bell Central: New Life for a Landmark* (Oklahoma City: Southwestern Bell Telephone, 1984), 3.

[30] Hrdy, interview with Silberman, 1 June 1980, "Kiowa-Olinka Hrdy, 1932-1982," Silberman papers, Dickinson Research Center.

[31] Father and son Amos William Rush and Edwin Arthur Rush formed E.A. Rush & Co., Architects in 1912, and in 1915, they admitted Asbury Endacott into the firm.

[32] For further information on Goff's interest in piano rolls, see DeLong, p. 38 and Pauline Saliga and Mary Woolever, *The Architecture of Bruce Goff, 1904-1982: Design for the Continuous Present* (Munich: Prestel-Verlag, 1995), 35-36. The inclusion of piano rolls in *Piano Music* is confirmed by "Artistic World Interested in Modernistic Tulsa Murals," *Tulsa Daily World*, 10 November 1929, sec. 4, p. 11.

[33] DeLong suggests that Goff may have read Bragdon's "Pattern from Magic Squares," *Architectural Forum* 26 (1917): 71-76; *Projective Ornament* (Rochester, NY: 1915); and "A Dissertation on Dynamic Symmetry," *Architectural Record* 56 (October 1924): 305-15. DeLong, p. 313, n. 34.

Iannelli's reference to "frozen music" does suggest that Goff had more than a passing familiarity with Bragdon's *Architecture and Democracy* (New York: Knopf, 1918), 543. See Goff to Iannelli, 13 September 1927, and Iannelli to Goff, 19 September 1927, quoted in De Long, p. 36.

Goff met Iannelli when the latter arrived in Tulsa in 1927 to execute the sculptural decoration of Francis Barry Byrne's Christ the King Catholic Church. The sculptor admired Goff's 1925 Tulsa Building and sought out Goff.

[34] "New Home for Music School," *Tulsa World*, 17 February 1929, p. 1.

[35] Hrdy exhibited all of the Hall watercolors at Iannelli's studio in Park Ridge, Illinois, on 17 March 1929 and one of the series at the McGee Art Shop in Tulsa in November 1929. Hrdy refers to the central figure of *Symphony of the Arts* as "Evelyn's figure dancing" in Hrdy, interview with Hoag, p. 8, and Hall is identified as the central figure in "Artistic World Interested in Modernistic Tulsa Murals," p. 11.

[36] *Webster's New World Dictionary of the American Language,* 2nd College Edition (New York: Simon and Schuster, 1984), 1418, 1509.

[37] Bruce Goff and Ernest Brooks, eds., *TULSART* 1, no. 1 (1 August 1931): 9. *TULSART* may be found in the Bruce Goff Papers, series V, box 1, Ryerson and Burnham Libraries, Art Institute of Chicago.

[38] Hrdy collected numerous magazines as source material. In particular, she examined *Vogue,* July 1927; an issue of *Harper's Bazaar,* 1929; and *Art in Architecture,* vol. 1, no. 1 April 1928. Her interest in Kent is confirmed by an exhibition catalogue from the Wanamaker Gallery of Modern Decorative Art in which she noted three works by the artist: *Man Carrying Tree, Alaska* and *Man with Black Sweater.* She was also impressed by a Pablo Picasso still life and a Jean Metzinger landscape. Hrdy probably saw the exhibit after her move to New York City in 1931. The magazines and the Wanamaker catalogue are in the possession of the Prague Historical Society.

[39] For a thorough discussion of Art Deco in Tulsa, see Susan Petersmeyer Henneke, ed., *Tulsa Art Deco* (Tulsa, Oklahoma: Tulsa Foundation for Architecture, 2001).

[40] DeLong, p. 36.

[41] Oscar Brousse Jacobson, "The Meaning of Modernism in Art," *The American Magazine of Art* 15, no. 1 (January 1924): 697-705.

[42] Russian modernist Wassily Kandinsky was the most vocal proponent of synaesthesia and explained the concept extensively in his key text, *Über das Geistige in der Kunst,* 1911. The book appeared in English as *Concerning the Spiritual in Art* in 1914, and although it is unknown whether Goff read the book, the concept of synaesthesia had currency among American modernists such as Arthur Dove and Georgia O'Keeffe.

[43] Jacobson referred to Synchromism as "Synchronism" but accurately noted that the paintings of artists such as Morgan Russell or Stanton MacDonald-Wright should be characterized as "a Beethoven sonata in color." Jacobson, p. 701. For further information on Synchromism, see Gail Levin, *Synchromism and American Color Abstraction, 1910-1925* (New York: George Braziller, Inc., 1978).

[44] "Artistic World Interested in Modernistic Tulsa Murals," p. 11, and Hrdy, interview with Hoag, pp. 8-9. It is worth noting that Schönberg was also a painter and exhibited with the Blue Rider, a German avant-garde group that also included Kandinsky.

Hrdy boasted that her translation of sound into form was so effective that the Kiowa Five began dancing when they saw her *Primitive Music.* The aforementioned article also reported Hrdy's anecdote that one "Indian boy" interpreted the mural as "Fire-dance music."

[45] Goff's recollection is quoted in Bill E. Peavler, "Bruce Goff's Riverside Music Studio," in Howard L. Meredith and Mary Ellen Meredith, eds., *Of the Earth: Oklahoma Architectural History* (Oklahoma City: Oklahoma Historical Society, 1980), 108-109.

[46] Bruce Goff, "Riverside Hall, Tulsa, Oklahoma," *Western Architect* 38, no. 12 (December 1929): 220.

[47] All three pieces were composed on 29 May 1931 and are entitled *Orientale – Voice in the Wilderness, Piano Trio (I and II),* and *Piano Trio (III and IV).* Goff Papers, series VIII, box FF, file 5, Ryerson and Burnham Libraries.

[48] Betty Kirk, "An Oklahoma Artist Wins Recognition," *Tulsa Daily World,* 17 March 1929, magazine section, p. 6.

[49] Hrdy's resume list the checklist for the McGee exhibition: *Bruce Goff; Self-Portrait;* the Turner Falls drawings; *Modern Refinery at Night; Abstract Mechanical Painting; Riding the Zingo; Monster; Dance Pose* (Evelyn Hall); *Mechanical Rhythm; Prisms; Light;* and *Abstraction.* "Kiowa-Olinka Hrdy, 1932-1982," Silberman Papers, box 10, folder 1, Dickinson Research Center. None of the paintings mentioned in the checklist seem to have survived, although she may have changed titles and reworked paintings later in her career. None of the dates were recorded. The Zingo referenced in *Riding the Zingo* is not the current ride at Bell's Amusement Park but a roller coaster at Tulsa's earlier park, Crystal City.

[50] Kirk, "An Oklahoma Artist Wins Recognition," p. 6.

[51] "Murals Of Hrdy Given Praise By Chicago Critics," *The Oklahoma Daily,* 17 January 1929, Hrdy Papers, AAA, LA 7: 1032; and "Paintings and Murals by Oklahoma Girl Accorded Exceptional Praise," *The Daily Oklahoman,* 15 September 1929, p. C5.

[52] "Convention Hall Is Being Made Over For Opera," *Tulsa Tribune,* 16 February 1930, sec. C, p. 7.

[53] Margaret Kentgens-Craig has demonstrated that Stölzl, though a significant figure at the Bauhaus, received little critical attention in the U.S. before 1936, possibly because the "male-dominated reception" of the Bauhaus focused almost solely on its male faculty. Kentgens-Craig, *The Bauhaus and America: First Contacts, 1919-1936* (Cambridge, Massachusetts: The MIT Press, 1999), 148. Further information on Stölzl and Bauhaus textiles may be found in Sigrid Wortmann Weltge, *Women's Work: Textile Art from the Bauhaus* (San Francisco: Chronicle Books, 1993).

[54] "Accomplishments," Hrdy Papers, Lincoln County Historical Society.

[55] Neither the dance studio nor the murals exist any longer.

[56] Hrdy mentioned her friendship with Matzene in Hrdy, interview with Silberman, 1 June 1980, tape 96.017.1040.028. Her knowledge of Buddhism is mentioned in Hrdy, postcard to Tom Toperzer, 2 May 1986, Curatorial Files, Fred Jones Jr. Museum of Art, University of Oklahoma, Norman.

[57] Hrdy's scholarship is listed in an unidentified article in Hrdy Papers, AAA, LA7: 1088.

[58] Hambidge issued several publications explaining his theories. The earliest, *Dynamic Symmetry,* was released in 1917 and discusses the system primarily in terms of Greek aesthetics. *Practical Applications of Dynamic Symmetry* (New Haven: Yale University Press, 1932), published posthumously by Hambidge's widow and taken from lectures given in 1921, remains the most useful text for linking Dynamic Symmetry and the arts.

59 "Portraiture in Prisms," *Tulsa Daily World*, 19 May 1935, in Hrdy Papers, AAA, LA8: 208. The article referred to the portrait as "Prismatic Phil." Goff's influence on the work may have also come through his lifelong love of crystals, which had originated in his fascination for his great-grandmother's collection. De-Long, "Bruce Goff Reconsidered," in Saliga and Woolever, p. 18.

60 Central High School, [Tulsa High School] Tulsa, Oklahoma, Graduating Class, 1925, 2001, http://freepages.genealogy. rootsweb.com/~bulger/25centralhigh-annotationsmno.htm, (accessed 23 August 2006).

61 Ruth Seinfel, "Whenas in Silks," *New York Evening Post*, 7 November 1932, Hrdy Papers, AAA, LA7: 1089. Further information on Schweizer may be found in "Dies Of Auto Injuries," *New York Times*, 21 November 1933, p. 42.

62 Hrdy, interview with Silberman, 1 June 1980, Tape 96.017.1040.028, Dickinson Research Center. Schweizer's claim is found in Seinfel, Hrdy Papers, AAA, LA7: 1089.

63 Hrdy, interview with Hoag, p. 12.

64 M de V, "Decker, Guild, Hrdy Shows Hang in Tulsa Galleries," *Tulsa Daily World*, 8 November 1936, sec. 4, p. 4.

65 For further information on O'Keeffe's use of the camera, see Elizabeth Kornhauser, et. al., *Stieglitz, O'Keeffe, and American Modernism* (Hartford, Connecticut: Wadsworth Atheneum, 1999).

66 Frank Lloyd Wright to Hrdy, 27 July 1933, Hrdy Papers, AAA, LA7: 1121.

67 Bob Mosher to Olinka Hrdy, 12 September 1933, Hrdy Papers, AAA, LA7: 1092. Hrdy's correspondence with Taliesin is located at The Getty Research Institute for the History of the Arts and Humanities. She is listed in the records as "Hardy, Olinka."

68 Hrdy to Frank Lloyd Wright, 14 March 1934, Frank Lloyd Wright Papers, Getty Research Institute, fiche no. H024D07. The Hillside to which Hrdy refers is likely the Hillside Home School, which Wright had originally designed in 1902 as his aunt's boarding school, but which became the center of the Taliesin campus.

69 The Public Works of Art Project was the first project of Franklin Delano Roosevelt's New Deal to offer financial assistance for artists affected by the Great Depression. Running between December 1933 and June 1934, the PWAP was replaced by the Federal Art Project, which was a part of the Works Progress Administration. The FAP, which ran between August 1935 and June 1943, supervised the creations of murals, easel paintings, prints, and posters.

Design (Exposition Park) was rediscovered in a warehouse by the staff of the Los Angeles County Museum of Art shortly following the 1992 Los Angeles Race Riots. Lacking documentation, the painting was given the title Design Exposition Park. Letter from Ilene Susan Fort to author, 1 September 2005. There is significant evidence that the proper title of the painting is *Design (Exposition Park)* and dates from 1934. The LACMA painting was a 1934 gift from the PWAP and Hrdy noted in her "Accomplishments" that *A Mysterious Shadow on Five Forms*

entered the collection of LACMA on 17 May 1934. "Accomplishments," Hrdy Papers, Lincoln County Historical Society. In addition, Hrdy provided a description of *A Mysterious Shadow on Five Forms* in a 1930s interview with the *Tulsa Tribune*: "Each form is laid on top of the other and being transparent toward the center creates other forms within forms. There being one form carried out differently … I filled it with gold leaf circles, each becoming larger as they go toward the cup. Over all five forms I've thrown a shadow at an angle across the canvas in a greyed green tone. The main colors are three deep grey blue values, Indian red gold, light green, and a grey green." Her description of the color scheme and forms describes the LACMA painting perfectly. M.B. "Views and Interviews," *Tulsa Tribune*, undated press clipping in "Kiowa-Olinka Hrdy, 1932-1982," Silberman Papers, box 10, folder 1, Dickinson Research Center.

70 László Moholy-Nagy, *The New Vision and Abstract of an Artist*, 3rd ed. (New York: Wittenborn and Company, 1946), 39.

71 *Sound Vibrations from Mars* was first completed in 1934, when it was probably exhibited as *Cosmic Movement*. She described a painting in a 1936 newspaper interview as "orange background – circles is called 'Cosmic Movement.'" Although it is possible that Hrdy may have been referring to another painting, the initial date of 1934 suggests that *Cosmic Movement* is *Sound Vibrations from Mars*, the title she likely adopted in 1953 when she modified the painting. Since no photographs of *Cosmic Movement* exist, it is impossible to say for certain. Hrdy exhibited *Cosmic Movement* and *Lake Shore* (a painting she identified solely as No. 2) at the WPA-Tulsa Art Association Gallery in Tulsa's Central Library in November 1934. The exhibition also included her portraits, landscapes (including Turner Falls), abstractions, figural abstractions, and flowers. The exhibition also included two paintings that are now lost: *No. 1* with waves that represent reasoning and *Movement in Space*, which was described as having a black background with white circles. "Decker, Guild, Hrdy Shows Hang in Tulsa Galleries," *Tulsa World*, 8 November 1936, sec. 4, p. 4.

72 Marianne Lorenz, "Kandinsky in Regional America," in Gail Levin and Marianne Lorenz, *Theme and Improvisation: Kandinsky and the American Avant-Garde, 1912-1950* (Boston: Bulfinch Press, 1992), 82-83, 229. Kandinsky regarded the circle as "a link with the cosmic … Of the three primary forms (triangle, square, circle), it points most clearly to the fourth dimension." Kandinsky to Grohmann, 12 October 1930, in Karl Gutbrod, ed., *Künstler schreiben an Will Grohmann* (Cologne: DuMont Schauberg, 1968), 56.

73 The American Abstract Artists formed in 1936; the Chicago Bauhaus under the direction of Moholy-Nagy opened in 1937; and the Museum of Non-Objective Painting under the direction of Hilla Rebay officially opened in 1939, although some of the exhibits showed in changing locations as early as 1931 when Hrdy lived in New York City.

74 Hrdy, interview with Arthur Silberman, 1980s, tape 96.017.1040.512, Silberman Papers.

75 This work was later recreated in paint and given to LACMA. She recorded the painting as *Lilies in Blue*, given to LACMA on 22 September 1936 and measuring 2½ x 3'. The painting is currently lost. "Accomplishments," Hrdy Papers, Lincoln County Historical Society. Hrdy's use of Dynamic Symmetry in the floral compositions is confirmed by "Hrdy Exhibition Novel; First Guild Show Opens," *Tulsa Daily World*, 1 November 1936, sec. 4, p. 2. The article illustrates the drawing *Tiger Lily* which has been lost.

76 Lorser Feitelson, to Olinka Hrdy, 18 April 1938, Hrdy Papers, AAA, LA8: 211.

77 Little information on *Festival of Foods* survives. Hrdy lists the title and date of completion as 25 February 1940 in "Accomplishments," Hrdy papers, Lincoln County Historical Society. Further information is provided in Arthur Millier, "The Art Thrill of the Week," *Los Angeles Times*, 11 August 1940, p. C9, and "Junior High School Pupils Approve Cafeteria Murals," *Los Angeles Times*, 25 February 1940, part 1.

78 The Gustave Gilbert exhibition is reviewed in "Art Exhibitions Reviewed," *Los Angeles Times*, 19 August 1934, p. A8. The Bullock's Wilshire exhibit is noted in Arthur Millier, "Brush Strokes," *Los Angeles Times*, 26 May 1935, p. A7. The Tulsa exhibition is noted in "Olinka Hrdy Exhibition Opens at Library Sunday," *Tulsa Daily World*, 25 October 1936, sec. 4, p. 2. The Stendahl exhibition in September is noted in Alma May Cook, "News of the Art World," *Los Angeles Evening Herald and Express*, 26 September 1936, sec. A, p. 10. Hrdy's exhibition at Stendahl's in November was a group exhibition with the graphics division of the Independent Artists and is noted in "Graphic Artists Stage Fine Exhibition," *Los Angeles Times*, 1 November 1936, p. C4. The exhibition at the Gallery of Modern Masters is listed in the Washington, D.C., *Evening Star*, 12 December 1936, sec. B, pg. 3.

79 Her mural commission is reported in "Residence Called Most Beautiful in State of California," *Long Beach Press-Telegram*, 24 January 1937, sec. A, pg. 10. In a telephone conversation with the author on 12 September 2006, one of the realtors of the property, Rochelle Kramer, confirmed that the mural no longer exists. Hrdy's "Accomplishments," Lincoln County Historical Society, lists the completion dates as 24 February 1937, and the mural as measuring 8 x 20' and depicting a waterfall in pastel.

80 Hrdy, interview with Hoag, p. 19.

81 The commendation titled "Win-the-War Award" is included in Hrdy Papers, AAA, LA7: 1098. In a telephone conversation with the author on 3 March 2006, a Boeing representative confirmed that following the merger with McDonnell Douglas in 1997 many of the historic records for the latter company were likely destroyed.

82 Hrdy, "Olinka Hrdy," Lincoln County Historical Society, p. 3.

83 Hrdy, interview with Hoag, p. 21.

84 Hrdy, "Olinka Hrdy," Lincoln County Historical Society, p. 4.

85 Hrdy, interview with Hoag, p. 25.

86 Design education for women was possible at institutions such as the Pratt Institute in Brooklyn, founded in 1887, and the Parsons School of Design in New York, founded in 1869.

87 Pat Kirkham, ed., *Women Designers in the USA, 1900-2000: Diversity and Difference*, 2nd ed. (New Haven, Connecticut: Yale University Press, 2002), 65.

88 Ella Howard and Eric Setliff, "In 'A Man's World': Women Industrial Designers," ibid., p. 269.

89 Kevin L. Stayton "Introduction" in Brooke Kamin Rapaport, et. al., *Vital Forms: American Art and Design in the Atomic Age, 1940-1960* (New York: Harry N. Abrams, Inc., 2002), 25.

90 Russel Wright, "Address at the Dedication of the WNYC murals," 2 August 1939, New York: WNYC Archives and the New York City Municipal Archives.

91 The radio cabinet was produced in a limited edition of three at a price of $1200. No extant cabinets have been discovered. Hrdy, interview with Hoag, p. 22.

92 Hrdy never named the company for which the radio designs were produced. One design, 1966.079.003, is dated 29 August 1945, and its similarity to the other two suggests that all may have been produced for the same company, although this has not been verified. The other two designs, 1966.079.011, were intended as plastic radios, suggesting that 1966.079.003 may have also been plastic.

93 Warren Susman, *Culture as History: The Transformation of American Society in the Twentieth Century* (New York: Pantheon, 1984), 160, and Jeffrey Meikle, *Twentieth Century Limited: Industrial Design in America, 1925-1939* (Philadelphia: Temple University Press, 1979), 98.

94 Hrdy, interview with Hoag, p. 20.

95 Ibid.

96 Ibid. Hrdy infers that the plastic radios and the other plasticware were designed for the same company.

97 Hrdy reports that the bee exhibit was originally designed for Exposition Park during her tenure as Chief Designer in Hrdy, interview with Hoag, p. 18; however, a newsletter entitled "Bee Business" from 1952 notes Hrdy's recent development of the exhibition. It is difficult to ascertain whether the exhibit was designed in the 1940s and exhibited again in 1952 or actually dates from the latter. The newsletter also reports that Hrdy was employed at the time by the technical writing division, indicating that she may have had more than one position during her tenure at Hycon.

98 Yvonne Litchfield, "Oklahoma Artist 'Genius of Imagination, Feeling,'" *Tulsa World*, 18 December 1975, in Silberman Papers, box 10, folder 1, Dickinson Research Center. For information on The Farm, see the organization's website http://www.thefarm.org.

99 Her plans were reported in "Olinka Hrdy to Publish Book," *Prague Times-Herald*, 24 November 1977, in Silberman Papers, box 10, folder 1, Dickinson Research Center.

Checklist

PLEASE NOTE: Unless otherwise noted all works are by Olinka Hrdy (U.S., 1902-1987) and are from the permanent collection of the Fred Jones Jr. Museum of Art, The University of Oklahoma, Norman. Dimensions listed are the image size; height precedes width and, if appropriate, depth.

Works are listed alphabetically by title, Olinka Hrdy's works preceding those by other artists.

*Works exhibited.
†Works digitally reproduced in the exhibition.

*Barley (Tablemat, Runner and Coaster Design), n.d.
Graphite, tempera, and watercolor on paper, 15 x 20"
Gift of the artist, 1966; 1966.079.001

*California Iris, n.d.
Lithograph on paper, 5½ x 3½"
Gift in memory of Shifra A. Silberman,1991; 1991.038.015

*California Orange Blossom, n.d.
Lithograph on paper, 5 ½ x 3 ½"
Gift in memory of Shifra A. Silberman, 1991; 1991.038.016

*Cartoon for Tulsa Convention Hall Curtain, c. 1930
Tempera on paper, 11 x 25"
Gift of the artist, 1966; 1966.075 (fig. 49; p. 40)

*Chalk Hill – California, 1937
Lithograph on paper, 14¾ x 20¼"
Gift of the artist, 1966; 1966.077.049 (fig. 62; p. 57)

*Conception, 1954
Oil on canvas, 24 x 24"
Gift of the artist, 1966; 1966.068 (fig. 70; p. 62)

*Daffodil, c. 1937
Lithograph on paper 13¾ x 11¾"
Gift of the artist, 1966; 1966.077.038 (fig. 5; p. 8)

*Day Lily, c. 1937
Lithograph on paper, 17¼ x 14¼"
Gift of the artist, 1966; 1966.077.037

Deep Sea Magic Mural, 1939
Tempera on plaster, 5' 11" x 19'
Will Rogers Middle School, Long Beach, CA
Photography © Will Rogers Middle School, Long Beach, CA
(figs. 63, 64, 65; p. 58)

*Design (Exposition Park) or Mysterious Shadow on Five Forms, 1934
Oil on canvas, 96½ x 60½"
Loan courtesy of the Los Angeles County Museum of Art, United States Government Treasury Department, Public Works of Art Project, Washington, D.C., permanent loan; Photography © 2006 Museum Associates/LACMA; L.1647.39 (fig. 55; p. 49)

*Designs for Wallpaper, n.d.
Tempera on paper, 19³/₈ x 28¹/₈"
Gift of the artist, 1966; 1966.078a

*Designs for Wallpaper, n.d.
Tempera on paper,15 x 20"
Gift of the artist, 1966; 1966.078c

*Designs for Wallpaper, n.d.
Tempera on paper, 19 ¼ x 28"
Gift of the artist, 1966; 1966.078d

*The Development of the Mind of the Greeks
(Mural Design for Central High School, Oklahoma City), 1928
Pen, ink and watercolor on paper, 15 x 18"
Gift of the artist, 1966; 1966.077.047 (fig. 27; p. 26)

*Dream Falls, 1929
Woodcut on paper, 9 x 12½"
Gift of the artist, 1966; 1966.077.007

*Fire Figure, c. 1929
Watercolor on paper, 12 x 10"
Gift of the artist, 1966; 1966.073 (fig. 46; p. 37)

*Five Suggestions for Clothes–Hampers, n.d.
Graphite and colored pencil on paper, 23 x 29"
Gift of the artist, 1966; 1966.079.012 (fig. 83; p. 72)

*Fern Leaf (Tablemat, Runner and Coaster Design), n.d.
Graphite, tempera and watercolor on paper, 23 x 29"
Gift of the artist, 1966; 1966.079.014

*Flower Drawing – A. Lily, c. 1936
Graphite on paper, 13 x 16¼"
Gift of the artist, 1966; 1966.077.021 (fig. 60; p. 54)

*Games, 1936
Oil on canvas, 36 x 24"
Gift of the artist, 1966; 1966.065 (fig. 57; p. 51)

*Hills Near Turner Falls, Oklahoma (Turner Falls No. 4), c. 1927
Colored pencil on paper, 20 x 26"
Gift of the artist, 1966; 1966.076.004

*Hybiscus (Tablemat, Runner and Coaster Design), n.d.
Tempera and graphite on paper, 15 x 20"
Gift of the artist, 1966; 1966.077.048 (fig. 80; p. 70)

*Jack Huston, 1932
Tempera on paper, 13 x 12"
Gift of the artist, 1966; 1966.071.005 (fig. 51; p. 43)

*Katharine Hepburn, early 1930s
Tempera and colored pencil on paper, 24 x 20"
Gift of the artist, 1966; 1966.071.004

*Lake Shore, c. 1933
Oil on canvas, 24 x 36"
Gift of the artist, 1966; 1966.066 (fig. 54; p. 47)

*Light, 1946
Oil on canvas, 24 x 24"
Gift of the artist, 1966; 1966.070 (fig. 72; p. 64)

*Linocut Block, n.d.
8 x 6"
Loan courtesy of the Prague Historical Museum

*Lotus, c. 1937
Colored pencil on paper, 11½ x 9½"
Gift of the artist, 1966; 1966.077.036 (fig. 61; p. 55)

*Magazine Rack, 1945
Graphite and colored pencil on paper, 14 x 17"
Gift of the artist, 1966 (fig. 77; p. 68); 1966.079.009

*Mildred Maxey, 1932
Tempera, colored pencil, and typing ink on paper, 14½ x 10"
Gift of the artist, 1966; 1966.071.009 (fig. 52; p. 44)

*Moving Sound, 1946
Oil and colored pencil on canvas, 36 x 24"
Gift of the artist, 1966; 1966.067 (fig. 68; p. 60)

Olinka Hrdy's Scrapbook (An Undated Postcard of Holmberg Hall with
Hrdy's Annotations Showing her Studio), n.d.
Microfilm (LA-940) Olinka Hrdy Papers
Archives of American Art, Washington, D.C.
Microfilm © Archives of American Art (fig. 14; p. 20)

Olinka Hrdy's Scrapbook (Design for Dalton Lain), c. 1929
Microfilm (LA-1072) Olinka Hrdy Papers
Archives of American Art, Washington, D.C.
Microfilm © Archives of American Art (fig. 45; p. 36)

Olinka Hrdy's Scrapbook
(Ebony Radio Cabinet for Hanson Music Company), 1945
Microfilm (LA-914) Olinka Hrdy Papers
Archives of American Art, Washington, D.C.
Microfilm © Archives of American Art (fig. 76; p. 68)

Olinka Hrdy's Scrapbook
(Exhibit for the Los Angeles Bee Keeper's Association), 1952
Microfilm (LA-915 & 1114) Olinka Hrdy Papers
Archives of American Art, Washington, D.C.
Microfilm © Archives of American Art (fig. 86; p. 73)

Olinka Hrdy's Scrapbook (Interior Design for a Douglas DC3), 1947
Microfilm (LA-916) Olinka Hrdy Papers
Archives of American Art, Washington, D.C.
Microfilm © Archives of American Art (fig. 66; p. 59)

Olinka Hrdy's Scrapbook
(Pageant of Food: Bananas and Pineapples), c. 1927
Microfilm (LA-1006) Olinka Hrdy Papers
Archives of American Art, Washington, D.C.
Microfilm © Archives of American Art (fig. 19; p. 22)

Olinka Hrdy's Scrapbook
(Pageant of Food: Coconuts and Pumpkins), c. 1927
Microfilm (LA-1008) Olinka Hrdy Papers
Archives of American Art, Washington, D.C.
Microfilm © Archives of American Art (fig. 19; p. 22)

Olinka Hrdy's Scrapbook
(Pageant of Food: King of the Fruits and Queen of the Flowers), c. 1927
Microfilm (LA-1007) Olinka Hrdy Papers
Archives of American Art, Washington, D.C.
Microfilm © Archives of American Art (fig. 20; p. 22)

Olinka Hrdy's Scrapbook (Pageant of Food: Study for an Untitled Self
Portrait for the Murals at the Copper Kettle), c. 1928
Microfilm (LA-1021) Olinka Hrdy Papers
Archives of American Art, Washington, D.C.
Microfilm © Archives of American Art (fig. 26; p. 25)

Olinka Hrdy's Scrapbook
(Pageant of Food: Watermelons and Fish), c. 1927
Microfilm (LA-1009) Olinka Hrdy Papers
Archives of American Art, Washington, D.C.
Microfilm © Archives of American Art (fig. 22; p. 23)

Olinka Hrdy's Scrapbook (Pageant of Food: Sea Foods and Rice), c. 1927
Microfilm (LA-1005) Olinka Hrdy Papers
Archives of American Art, Washington, D.C.
Microfilm © Archives of American Art (fig. 18; p. 22)

Olinka Hrdy's Scrapbook (Riding the Zingo or The Zingo Ride), c. 1929
Microfilm (LA-1070) Olinka Hrdy Papers
Archives of American Art, Washington, D.C.
Microfilm © Archives of American Art (fig. 44; p. 36)

Olinka Hrdy's Scrapbook (Solar Hill, Woodland Hills, California), 1950
Microfilm (LA-1108) Olinka Hrdy Papers
Archives of American Art, Washington, D.C.
Microfilm © Archives of American Art (fig. 67; p. 59)

Olinka Hrdy's Scrapbook (Spiritual Experiments), 1950
Microfilm (LA-1118) Olinka Hrdy Papers
Archives of American Art, Washington, D.C.
Microfilm © Archives of American Art (fig. 69; p. 61)

Olinka Hrdy's Scrapbook (Untitled Batik Design), n.d.
Microfilm (LA-984) Olinka Hrdy Papers
Archives of American Art, Washington, D.C.
Microfilm © Archives of American Art (fig. 10; p. 16)

Olinka Hrdy's Scrapbook (Untitled Studies for Maker of Dreams), c. 1925
Microfilm (LA-945) Olinka Hrdy Papers
Archives of American Art, Washington, D.C.
Microfilm © Archives of American Art (fig. 16; p. 21)

Olinka Hrdy's Scrapbook (Untitled Studies for Maker of Dreams), c. 1925
Microfilm (LA-944) Olinka Hrdy Papers
Archives of American Art, Washington, D.C.
Microfilm © Archives of American Art (fig. 17; p. 21)

Olinka Hrdy's Scrapbook (Untitled Studies for Maker of Dreams), c. 1925
Microfilm (LA-946) Olinka Hrdy Papers
Archives of American Art, Washington, D.C.
Microfilm © Archives of American Art (fig. 15; p. 21)

*Olinka's Palette
Oil on metal, 22½ x 16¼"
Loan courtesy of the Lincoln County Historical Society Museum of
Pioneer History, Chandler, Oklahoma

*Office—Wastebasket,, n.d.
Graphite and colored pencil on paper, 36 x 24"
Gift of the artist, 1966; 1966.079.005 (fig. 84; p. 72)

*Phil McMann, early 1930s
Tempera and colored pencil on paper, 13 x 12"
Gift of the artist, 1966; 1966.071.008 (fig. 53; p. 45)

*Portrait of Oscar B. Jacobson, 1928
Graphite on paper , 4½ x 4 ¾"
Loan courtesy of the National Cowboy & Western Heritage Museum
1996.27.0489 (fig. 1; p. 7)

*Price's Falls, c. 1926
Colored pencil on paper, 9 x 12"
Gift of the artist, 1966; 1966.077.002 (fig. 12; p. 18)

*Radio Design, 1945
Graphite and colored pencil on paper, 14 x 17"
Gift of the artist, 1966; 1966.079.003 (fig. 78; p. 69)

*Radio Design, c. 1945
Graphite and colored pencil on paper, 23 x 29"
Gift of the artist, 1966; 1966.079.011 (fig. 79; p. 69)

*Radio Cabinet, c. 1950
Gelatin silver print, 7⅛ x 8⅝"
Gift of the artist, 1966; 1966.077.052 (fig. 85; p. 73)

*Rock Window, 1930s
Lithograph on paper, 13 x 11¼"
Gift of the artist, 1966; 1966.077.022

*Self-Portrait, July 7, 1934
Tempera on paper, 13 x 12"
Gift of the artist, 1966; 1966.071.002 (fig. 6; p. 10)

*Sex, March 22, 1954,
Oil on canvas, 24 x 24"
Gift of the artist, 1966; 1966.069 (fig. 71; p. 63)

*Sound Vibrations from Mars (Cosmic Movement), 1934-53
Oil on canvas, 36 x 24"
Gift of the artist, 1966; 1966.064 (fig. 58; p. 52)

*Spavinaw, 1927
Colored pencil on paper, 8¾ x 12"
Gift of the artist, 1966; 1966.077.009

*Spavinaw, 1927
Woodcut on paper, 12¾ x 15½"
Gift of Mr. and Mrs. Leonard Good, 1991; 1991.041.007

*Study for Tulsa Riverside Studio Murals: Piano Music, 1928-29
Watercolor on paper, 18 x 4½"
Gift of the artist, 1966; 1966.074.006 (fig. 35; p. 30)

*Study for Tulsa Riverside Studio Murals: Primitive Music, 1928-29
Watercolor on paper, 18 x 4½"
Gift of the artist, 1966; 1966.074.003 (fig. 38; p. 31)

*Study for Tulsa Riverside Studio Murals: Vocal Music, 1928-29
Watercolor on paper, 18 x 4½"
Gift of the artist, 1966; 1966.074.005 (fig. 34; p. 30)

*Study for Tulsa Riverside Studio Murals: Choral Music, 1928-29
Watercolor on paper, 18 x 4½"
Gift of the artist, 1966; 1966.074.008 (fig. 39; p. 31)

*Study for Tulsa Riverside Studio Murals:
Modern American Music, 1928-29
Watercolor on paper, 18 x 4½"
Gift of the artist, 1966; 1966.074.004 (fig. 33; p. 30)

*Study for Tulsa Riverside Studio Murals: Music of the Future, 1928-29
Watercolor on paper, 18 x 4½"
Gift of the artist, 1966; 1966.074.009 (fig. 40; p. 31)

*Study for Tulsa Riverside Studio Murals: String Music, 1928-29
Watercolor on paper, 18 x 4½"
Gift of the artist, 1966; 1966.074.007 (fig. 36; p. 30)

*Study for Tulsa Riverside Studio Murals: Orchestra Music, 1928-1929
Watercolor on paper, 18 x 4½"
Gift of the artist, 1966; 1966.074.002 (fig. 37; p. 31)

*Study for Tulsa Riverside Studio Murals: Symphony of the Arts, 1928-29
Watercolor on paper, 23¾ x 10½"
Gift of the artist, 1966; 1966.074.001 (fig. 32; p. 29)

*Textile Designs for Plastic Mats–Runners–Coasters, n.d.
Graphite on paper, 17 x 14"
Gift of the artist, 1966; 1966.079.004 (fig. 82; p. 71)

*Turner Falls, Okla., 1930s
Lithograph on paper, 13¾ x 11½"
Gift of the artist, 1966; 1966.077.042

*Turner Falls, Oklahoma, 1926
Colored pencil on paper, 12½ x 15"
Gift of Mr. and Mrs. Leonard Good, 1991; 1991.041.006

*Turner Falls, Oklahoma, c. 1926
Colored pencil on paper, 9 x 12"
Acquisition, 1950s; 1878

*Turner Falls, Oklahoma (Turner Falls No. 1), c. 1927
Colored pencil on paper, 20 x 26"
Gift of the artist, 1966; 1966.076.001 (fig. 13; p. 19)

*Turner Falls, Oklahoma (Turner Falls No. 2), c. 1927
Colored pencil on paper, 20 x 26"
Gift of the artist, 1966
1966.076.002 (fig. 8; p. 14)

*Turner Falls, Oklahoma (Turner Falls No. 3), c. 1927
Colored pencil on paper, 20 x 26"
Gift of the artist, 1966; 1966.076.003

*Untitled, c. 1936
Watercolor and colored pencil on paper, 14½ x 11½"
Gift of the artist, 1966; 1966.077.020 (fig. 2; p. 8)

*Untitled, c. 1937
Watercolor and colored pencil on paper, 13 x 11"
Gift of the artist, 1966; 1966.077.023 (fig. 4; p. 8)

*Untitled, c. 1937
Watercolor and colored pencil on paper, 11½ x 10"
Gift of the artist, 1966; 1966.077.025

*Untitled, c. 1937
Watercolor and colored pencil, 14½ x 11½"
Gift of the artist, 1966; 1966.077.026 (fig. 3; p. 8)

*Untitled, 1937
Colored pencil on paper, 11½ x 9¾"
Gift of the artist, 1966; 1966.077.027

*Untitled, c. 1937
Colored pencil on paper, 12¾ x 12"
Gift of the artist, 1966; 1966.077.028

*Untitled, 1937
Colored pencil on paper, 11½ x 10"
Gift of the artist, 1966; 1966.077.035 (fig. 81; p. 70)

*Untitled, c. 1937
Colored pencil on paper, 11½ x 10"
Gift of the artist, 1966; 1966.077.041

*Untitled, n.d.
Oil on paper 8 x 26½"
Gift in memory of Shifra A. Silberman, 1991
1991.038.012 (fig. 74; pp. 66-67)

*Untitled, c. 1937
Watercolor and colored pencil on paper, 11½ x 9"
Gift of the artist, 1966; 1966.077.001

*Untitled (Abstract), n.d.
Ink on paper, 12 x 9"
Loan courtesy of the Prague Historical Museum

*Untitled (Chalk Hill, California), c. 1937
Graphite on paper, 20 x 24"
Gift of the artist, 1966; 1966.077.046

*Untitled, n.d.
Tempera on paper, 15 x 20⅛"
Gift of the artist, 1966; 1966.079.010

*Untitled (Flatware Competition Entry for Holmes and Edwards), c. 1929
Ink and graphite on paper, seven panels, each: 11 x 5¾"
Loan courtesy of the Prague Historical Museum (figs. 47A, 47B; p. 38)

*Weaving, 1936
Oil on board, 24 x 36"
Gift of the artist, 1966; 1966.063 (fig. 9; p. 15)

The works listed below are by artists other than Olinka Hrdy:

*B.A. Botkin, 1929
Folk-Say: A Regional Miscellany, 2nd ed. (Norman: University of
Oklahoma Press), Book, 9¼ x 6¼ x ½"
Loan courtesy of the University of Oklahoma Libraries, Western History Collection. B.A. Botkin © Estate of B.A. Botkin

Arthur Dove (U.S. 1880-1946)
George Gershwin - I'll Build a Stairway to Paradise, 1927
Ink, metallic paint, and oil on paperboard, 20 x 15"
Museum of Fine Arts Boston
Gift of the William H. Lane Foundation, 1990
Arthur Dove © Courtesy of the Estate of Arthur Dove (fig. 42; p. 34)

*Sam Francis (U.S. 1923-1994)
Untitled, 1983
Acrylic on rice paper, 72 x 37¼"
Gift of Jerome M. and Wanda Otey Westheimer, Sr. , 1999
Sam Francis © Samuel L. Francis Foundation, Los Angeles /
Artist Rights Society (ARS), New York; 1999.014 (fig. 75; p. 67)

†Bruce Alonzo Goff (U.S. 1904-1982)
Composition No. 255, c. 1925-1940
Tempera on drawing paper mounted on board, 25½ x 19¾"
The Art Institute of Chicago, Gift of Shin'enKan, Inc.
Photography © The Art Institute of Chicago
Bruce Alonzo Goff © The Art Institute of Chicago; 1990.574.255

†Bruce Alonzo Goff (U.S. 1904-1982)
Composition No. 294, 1930
Tempera on paper mounted on board, 29 x 23"
The Art Institute of Chicago, Gift of Shin'enKan, Inc.
Photography © The Art Institute of Chicago
Bruce Alonzo Goff © The Art Institute of Chicago; 1990.574.294

†Bruce Alonzo Goff, U.S. 1904-1982
Shriner, Patti Adams House and Studio, number 2, Tulsa, Oklahoma:
Interior Perspective of Entrance Lobby, 1928
Graphite and colored pencil on tracing paper, 10½ x 15¾"
The Art Institute of Chicago, Gift of Shin'enKan, Inc.
Photography © The Art Institute of Chicago
Bruce Alonzo Goff © The Art Institute of Chicago; 1990.82.6

†Bruce Alonzo Goff (U.S. 1904-1982)
Shriner, Patti Adams House and Studio, number 2, Tulsa, Oklahoma:
Perspective Elevation of View Toward Public Entrance, Circular Window Scheme, 1928 ; Van Dyke sepia print; The Art Institute of Chicago,
Gift of Shin'enKan, Inc.; Photography © The Art Institute of Chicago;
Bruce Alonzo Goff © The Art Institute of Chicago
1990.82.11 (fig. 29; p. 28)

†Bruce Alonzo Goff (U.S. 1904-1982)
Shriner, Patti Adams House and Studio, number 2, Tulsa, Oklahoma:
Presentation Plan: "Patti Adams School of Music, Studio & Home", 1928
Ink and graphite on white tracing paper, 33 x 24½"; The Art Institute of
Chicago, Gift of Shin'enKan, Inc.; Photography © The Art Institute of
Chicago; Bruce Alonzo Goff © The Art Institute of Chicago
1990.82.10 (fig. 30; p. 28)

†Bruce Alonzo Goff (U.S. 1904-1982)
Shriner, Patti Adams House and Studio, number 2, Tulsa, Oklahoma:
Showing Preliminary Facade Treatment, 1928
Graphite and colored pencil on laid paper, 21 x 16¾"; The Art Institute
of Chicago, Gift of Shin'enKan, Inc.; Photography © The Art Institute
of Chicago Bruce Alonzo Goff © The Art Institute of Chicago
1990.82.5 (fig. 31; p. 28)

†Bruce Alonzo Goff (U.S. 1904-1982)
View of Olinka Hrdy in Cubist Costume, c. 1929
Series III, box 22, folder 18.22 (Goff papers); Digital reproduction, 29⁵/₁₆ x 37⁵/₁₆"; Loan courtesy of the Bruce Goff Archive, Ryerson and Burnham Archives, The Art Institute of Chicago; Digital file © The Art Institute of Chicago; Bruce Alonzo Goff © The Art Institute of Chicago 1990.82.10 (fig. 43; p. 35)

†Bruce Alonzo Goff (U.S. 1904-1982), Ernest Brooks & Olinka Hrdy
Piano Trio, Parts 1-4, Orientale and Voice in the Wilderness, n.d.
Sound Recording; Loan courtesy of the Bruce Goff Archive, Ryerson and Burnham Archives, The Art Institute of Chicago. Sound Recording © The Art Institute of Chicago; Bruce Alonzo Goff © The Art Institute of Chicago. 1990.82.10

*Jay Hambidge
Practical Applications of Dynamic Symmetry (Yale University Press, 1932)
Book, 8¾ x 5¾ x ¾"
Loan courtesy of the University of Oklahoma Libraries
Jay Hambidge © Reprint granted by The Hambidge Center for Creative Arts and Sciences, Rabun Gap, Georgia (fig. 50; p. 42)

*June Johnson
Outdoor-Indoor Fun Book (New York: Gramercy, 1961)
Book, 8¼ x 5⁵/₈ x 1"
Loan courtesy of Price Tower Arts Center, Bartlesville, Oklahoma
June Johnson © Random House (fig. 87; p. 74)

Wassily Kandinsky (Russia 1866-1944)
Circles in a Circle, 1923
Oil on canvass, 38⁷/₈ x 37⁵/₈"
Philadelphia Museum of Art, The Louise and Walter Arensberg Collection, 1950; Wassily Kandinsky © Artist Rights Society (ARS), New York 1950.134.104 (fig. 59; p. 53)

Wassily Kandinsky (Russia 1866-1944)
Composition IX, 1936
Oil on canvas, 44⁵/₈ x 76¾"
Musee National d'Art Moderne, Centre Georges Pompidou, Paris, France. Photo Credit: CNAC/MNAM/Dist. Réunion des Musées Nationaux / Art Resource, New York; Wassily Kandinsky © Artist Rights Society (ARS), New York; JP 890 BIS P (fig. 73; p. 65)

László Moholy-Nagy (Hungary 1895-1946)
Composition Z VIII, 1924
Glue print on canvas, 45 x 52"
Nationalgalerie, Staatliche Museen zu Berlin, Germany. Photo Credit: Bildarchiv Preussischer Kulturbesit / Art Resource, New York
Laszlo Moholy-Nagy / Photography © Jens Ziehe; Laszlo Moholy-Nagy © Artist Rights Society (ARS), New York (fig. 56; p. 50)

*Margaret Preininger
Japanese Flower Arrangement for Modern Homes (Boston: Little, Brown, and Company), 1936
Book, 12¼ x 9⁵/₈ x ¾"

Sooner Magazine
vol. 1, no. 10 (July 1929): 344; Frontispiece for the *Pageant of Food* (Mural Section from the Copper Kettle, Reproduced in Jeanne d'Ucel's "Olinka Hrdy: Her Genius Wins Applause in the Art World Through Modern Masterpieces"), 1929; Loan courtesy of the University of Oklahoma Libraries, Western History Collection
Sooner Magazine © The University of Oklahoma (figs. 24-25; pp. 24-25)

Paul Stithem
Riverside Studio Interior View, c. 1929 1990.1 series III, box 2, folder 28.14; Digital reproduction; Loan courtesy of the Bruce Goff Archive, Ryerson and Burnham Archives, The Art Institute of Chicago. Digital file © The Art Institute of Chicago; Paul Stithem Image © The Art Institute of Chicago (figs. 41A-41B; pp. 32-33)

The Tulsa Spirit
Official Publication of the Tulsa Chamber of Commerce (*Convention Hall Goes Moderne*), March 1930; Digital scan; Image courtesy of the National Cowboy & Western Heritage Museum, Donald C. & Elizabeth M. Dickinson Research Center (fig. 48A-48B; p. 39)

University of Oklahoma Magazine
Illustration for Spencer Barefoot, "The Yellow Cat," vol. 16, no. 2 (Winter 1928): 15; Loan courtesy of the University of Oklahoma Libraries, Western History Collection; *University of Oklahoma Magazine* © The University of Oklahoma

Unknown Artist
Postcard of the Copper Kettle - Norman Oklahoma, n.d.
Postcard, 11 x 25"
Collection of Hal and Lucretia Ottaway (fig. 23; p. 24)

University of Oklahoma Magazine
Illustration for Richard Caldwell, "Fountain Moon for M.J.," vol. 14, no. 4 (Summer 1926): 28: Landscape with Falls; Loan courtesy of the University of Oklahoma Libraries, Western History Collection
University of Oklahoma Magazine © The University of Oklahoma

University of Oklahoma Magazine
"An Art Student's Conception of Dr. Bizzell's Plan for the Campus, Showing the Proposed New Library in the Background," vol. 14, no. 3 (Spring 1926): cover; Loan courtesy of the University of Oklahoma Libraries, Western History Collection; *University of Oklahoma Magazine* © The University of Oklahoma (fig. 11; p. 17)

*Unknown Artist
Olinka Hrdy, 1931
Gelatin silver print, 10 x 8"
Gift of Olinka Hrdy, 1966; 1966.077.019 (fig. 28; p. 27)

*Unknown Artist
Olinka Hrdy, 1965
Gelatin silver print, 10 x 8"
(fig. 88; p. 76)

*Unknown Artist
Olinka Hrdy is shown at Solar Hill in the top photo,1969.
She is pictured in front of her family's log cabin near Prague, Oklahoma, 1975 in the bottom two photos; Loan courtesy of the Lincoln County Historical Society Museum of Pioneer History, Chandler, Oklahoma (fig. 7A, 7B; pp. 12, 13)

*Lawrence Williams (U.S. 1899-1929)
Portrait of Olinka Hrdy, 1927
Oil on canvas, 18 x 15½"
Gift of Mr. and Mrs. Leonard Good, 1991; 1991.041.005

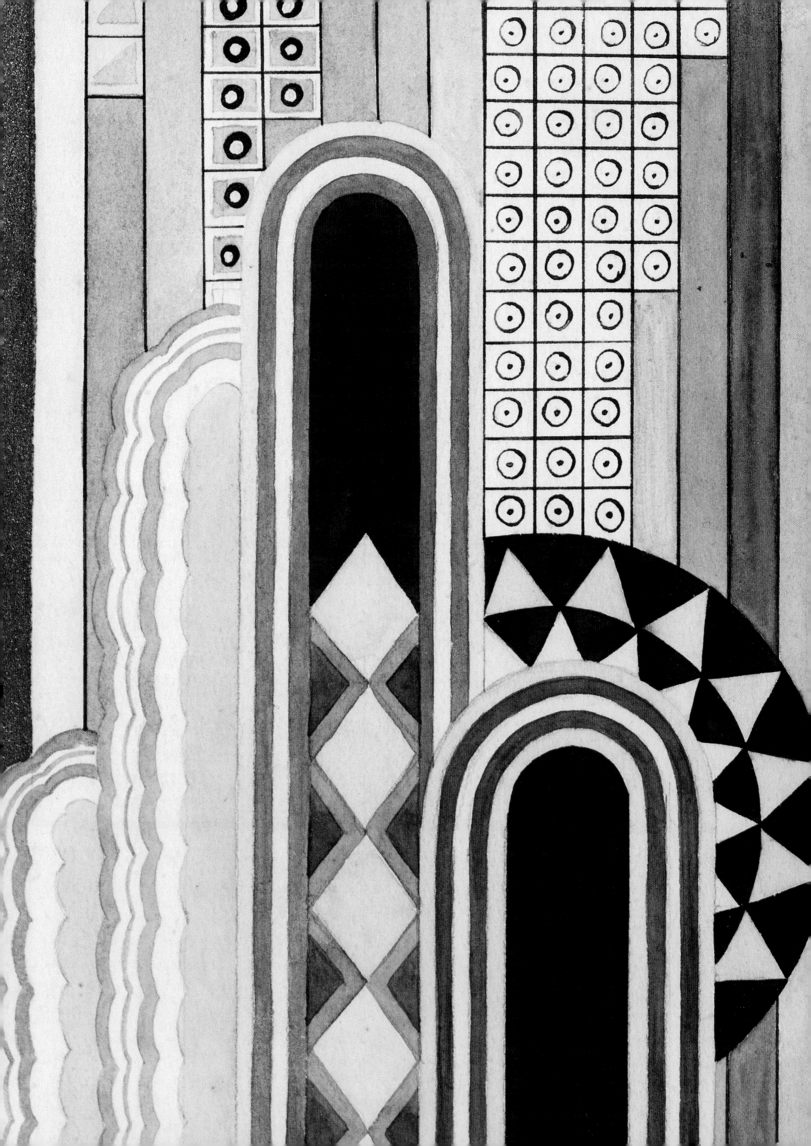

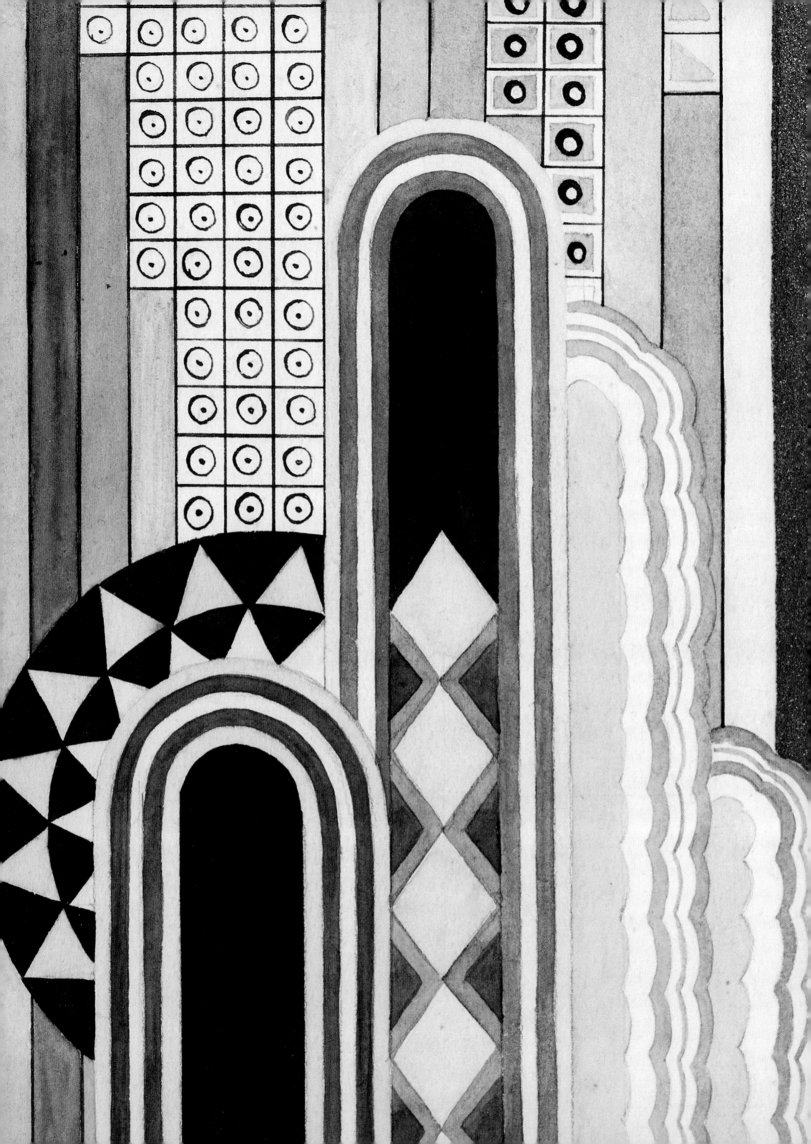